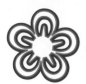

D1373492

Flowers From My Garden

IRON-ON TRANSFERS

Designs by June Fiechter, Kathleen Hurley, Samantha McNesby,
Darlene Polachic, Vicki Schreiner and Barbara Sestok

Edited by Vicki Blizzard

HOUSE of
WHITE
BIRCHES
PUBLISHERS
SINCE 1947

Flowers From My Garden

Editor: Vicki Blizzard
Associate Editor: Kelly Keim
Project Editor: Marla Freeman
Copy Editors: Nicki Lehman, Mary Martin

Photographers: Jeff Chilcote, Tammy Christian
Kelly Heydinger, Justin P. Wiard
Photography Assistant: Linda Quinlan

Publishing Services Manager: Brenda Wendling
Graphic Artists Supervisor: Ronda Bechinski
Production Coordinator: Brenda Gallmeyer
Project Book and Iron-on Transfer Book Production:
Kristen Sprunger
Cover Design: Jessi Butler

Publishers: Carl H. Muselman, Arthur K. Muselman
Chief Executive Officer: John Robinson
Marketing Director: Scott Moss
Book Marketing Manager: Craig Scott
Product Development Director: Vivian Rothe

Printed in the United States of America
First Printing: 2002
Library of Congress Number: 00-112311
ISBN: 1-882138-82-1

Flowers From My Garden

I have a little brown bunny who lives in my garden all year long. I never quite get around to pulling out the spent plants at the end of summer, so he's sheltered by the brown cornstalks and branches of tomato plants in the late fall and during the winter. In the early spring he hops out to watch me turn over the soil in my raised vegetable beds and twitches his nose at me as I plant peas. And during the summer, he lies in the shade of the marigolds I've planted to keep him from nibbling my vegetable plants. My little brown bunny and I really enjoy my garden.

We've gathered together illustrations from several artists who share that same love of gardening and flowers. Included in this book are transfers for all sorts of garden creatures, flowers of every size and shape, garden vignettes, mini motifs to use in little spaces, flower expressions and garden fairies and angels. From whimsical to elegant, you're sure to find a flower motif for any use you can imagine.

The project book that accompanies this transfer book will help you to create lovely projects for your home, to wear or to give as gifts. Make the projects as they appear, or use them as inspiration with other transfers from this book.

Pull up a chair on the deck, sip some iced tea, and page through the illustrations in this book. Be sure to have a pen and paper handy to jot down notes about all the projects you'll want to make using these designs!

Vicki Blizzard

Contents

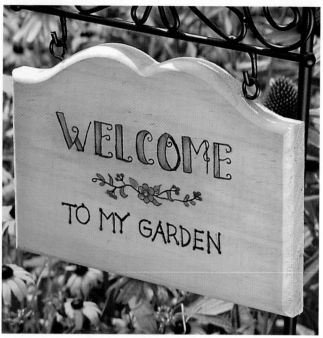

Say It With Flowers

Busy Bees, Bugs & Birds

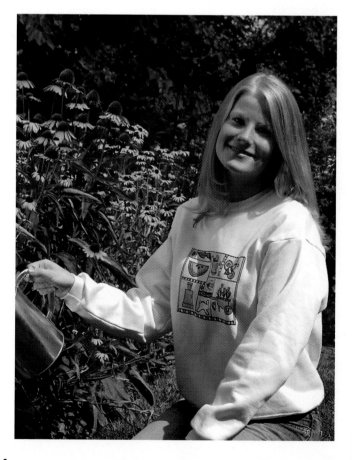

Garden Friends

Elegant Arrangements

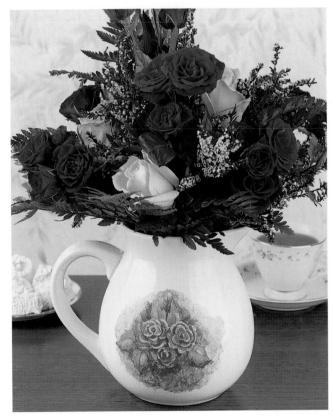

Garden Views

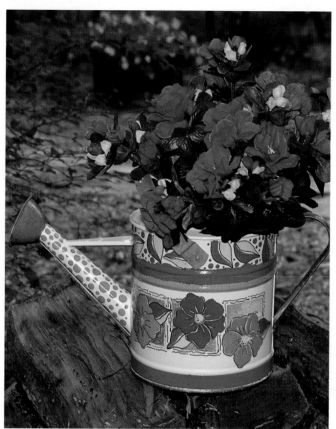

All in a Row

Floral Motifs

Alphabets for Personalization

General Instructions

General Materials List

Crafters use a wide variety of supplies, tools and equipment when they are creating projects. Each of the projects in this book includes a materials list for making the design shown in addition to the following standard items:

Tracing paper and pencil; soft eraser; colored pencils and markers; cardboard or poster board; light and dark graphite paper; stylus or ball point pen; light table or bright window; tape: heat-resistant masking and cellophane; black permanent marker: extra-fine-, fine- and medium-point; water-soluble marking pen; hot-glue gun; hand-sewing needle and thread; scissors: sewing, mini craft and pinking shears; paintbrushes: flat, round, shading and liner; wide foam brush; sponge: cellulose and natural; paper towels; paint palette or plastic plate; toothpicks; toothbrush; sawtooth hangers; wire cutters; sandpaper: coarse and fine; tack cloth; iron; sewing machine; scroll saw or jigsaw; electric drill.

Transferring Designs

Ironing-on Transfers

Determine the best temperature setting for your iron and length of time needed for a good transfer by using the test transfer on each page.

Cut chosen design out of book; place face down onto right side of fabric, paper or unpainted wood. *Note: When transferring onto fabric, use light-colored fabric; wash and dry without fabric softener before applying transfer design.*

Place hot, dry iron flat on the transfer for five seconds. Do not move iron around. Pick up iron and place on another area of transfer until all areas have been ironed. Lift corner of paper to ensure proper transfer of design.

Fill in and add detail using fabric paints, colored pencils, markers, watercolor paints, etc.

Transfer Markers

The ink on iron-on transfers will produce good, sharp images for only a finite number of transfers. When the transferred image becomes faint, revive it by marking over design lines with a transfer pen or pencil. These are available in craft, fabric and quilting stores.

Ironing-on Photocopied Images

Freshly photocopied images are iron-on transfers in disguise. Simply position the photocopied image on the surface, ink side toward the surface. Apply dry heat appropriate for the surface with firm pressure.

This works best on light surfaces with a photocopy less than 48 hours old—the fresher the copy, the better the transfer. Just remember, the transferred image will be a mirror image of what you see. To change orientation, see Tips for Using Iron-On Transfers on this page.

Using Graphite Paper

Cut the chosen design from the book, or make a photocopy. Place a sheet of the graphite paper between the surface and the design; trace the design lines with pointed pencil, ball point pen or stylus. Use light-colored graphite for the dark surfaces; use dark-colored graphite for the light surfaces.

Using Transfers for Appliqué

Making a Paper Pattern

Trace individual pattern pieces onto tracing paper with pencil, extending pattern where pieces overlap. Lightly mark each piece with pencil to indicate right side of pattern. Cut out slightly inside traced lines.

No-Sew Appliqué

Make paper patterns; place right side down on paper side of fusible web and trace. Cut out slightly outside traced lines. Following manufacturer's directions, fuse web onto fabric; cut out on traced lines.

Hand Appliqué

Make paper patterns; place right side down on wrong side of fabric and trace, adding ⅛" seam allowance. Turn under seam allowance and hand-stitch to fabric.

Machine-Appliqué

Make paper patterns; place right side down on wrong side of fabric and trace. Cut out on traced lines. Outline appliqué using medium-width satin stitch in coordinating or contrasting thread.

Tips for Using Iron-on Transfers

Changing the Size of the Transfer Image

Most copy centers, libraries, business centers, printers and office-supply stores have photocopy machines that can enlarge or reduce the size of any motif. Ask them to copy the transfer at a percentage of the original (anything larger than 100 percent will enlarge the image; anything smaller than 100 percent will reduce it). The image may then be transferred onto your chosen surface.

Changing the Orientation of the Transfer Image

If figures and motifs (not words) are pointing the wrong direction for your project, take the transfer to a copy center or business center. Most will have a photocopy machine that can print a mirror image of the original. The image may then be transferred to your chosen surface.

Another way to flip the images is to place the transfer on the surface, image side up. Slip a piece of graphite or dressmaker's carbon between the surface and transfer. Trace over the design lines with a pencil or ball point pen to transfer the image to the surface.

Adapting the Transfer Shape

Iron-on transfer shapes can be changed to accommodate the desired surface by cutting and pasting pieces of design using heat-resistant tape (available in fabric and quilting stores).

Making Cross-Stitch, Plastic Canvas or Needlepoint Charts

To turn iron-on into a cross-stitch, plastic canvas or needlepoint pattern, photocopy iron-on at 200 percent, then copy again onto graph paper. Color squares with colored pencils. Work on even-weave fabric, such as Aida cloth, using design colored with colored pencils as a chart.

Words may be added or deleted, as desired. Simply cut words out of iron-on before applying heat to transfer design.

Experimenting With Transfer Designs

Don't be afraid to experiment. Make several photocopies for

just a few pennies. These can be cut up and rearranged many times until the design is just right for your project. Then cut the iron-on transfer and arrange it like the photocopies before transferring the image onto the desired surface.

Design Techniques

Painting & Coloring

Disposable paper or plastic plates, including supermarket meat trays, make good palettes for pouring and mixing paints.

Allow painted areas to dry before applying adjacent colors.

Use the brush sizes with which you are most comfortable unless otherwise indicated. A large area should be painted with a flat paintbrush. A small, round paintbrush works best to get into tight, detailed areas and a wide foam brush works best for glazing.

Sponge Painting

Dampen natural sponge with water; squeeze out. Dip sponge in paint, then blot excess on paper towel; press sponge randomly over surface.

Float Shading

Dip flat brush in water; blot shine off on paper towel. Dip one brush corner in paint; spread paint across brush by brushing back and forth in one place on palette. Apply to project.

Dry Brushing

Dip old, scruffy brush in paint; wipe off most of the paint on a paper towel. Practice first on scrap paper, then rub "dry" brush on wood. Repeat as necessary to highlight or shade areas. Errors can be wiped off with a damp sponge or paper towel if done immediately.

Glazing

Scrunch plastic wrap and dip into paint mixture; blot plastic wrap on foam plate, then press on surface to glaze. *Note: Practice on scrap paper first.*

Spatter Painting

Mix paint with water, adding more water to make larger spatters and less water to make smaller spatters. Dip toothbrush in paint; brush across bristles with thumb or stick, directing spatters over work surface. Immediately wipe off any unwanted paint spatters with a damp sponge. Let dry.

Dot Hearts

Place two dots of same-color paint side by side. Join dots at the base by pulling one dot into the other into a point. Practice several times on scrap paper until the technique feels comfortable.

To make hearts into flowers, add leaves at base of heart by squeezing a dot of green paint and drawing it to a point with the bottle tip, brush or toothpick.

Colored Pencils

When working with colored pencils, colors may be shaded to give the image depth, but it is difficult to add highlights with a lighter pencil. Work with lightest pressure on areas where sunlight would touch the design; use heaviest pressure where shadows would fall.

Marking Pens

When outlining or filling in with a marking pen, always test marker on surface material first to be sure it will not "bleed." Also check marker on wood surface to be sure it will not run when varnished. Thinned acrylic paint and liner brush may be substituted for marker.

Stenciling

Mask off one color area at a time to keep colors from mixing into unworked sections. Dab stencil brush lightly into stencil paint, then blot on paper towel to remove excess paint.

Holding brush straight up and down, lightly apply paint to the surface using a circular or sweeping motion. Concentrating colors toward the edges of the pattern will create a shading effect.

Adding Glitter

To add glitter to fabric designs, use a glitter paint or sprinkle dry (garment-grade) glitter on paints or dyes while still wet. Shake excess glitter onto a piece of paper that has been folded and opened up again. Use the fold to funnel glitter back into bottle for future use.

Add glitter to designs on paper by applying a light coat of glue (appropriate for the surface) in desired area; sprinkle glitter on. Press lightly with fingers to set glitter into glue. Dry; return excess glitter to the bottle for future use.

Bias Trim

To make bias trim cut 2"-wide strips on the bias from fabric. Place two strips at a right angle to one another with ends overlapping; sew across ends diagonally. Trim seam; press open. Repeat until joined strips measure desired length. Press one long edge under ½".

Embroidered Embellishments

Outline and embellish fabric designs with machine- or hand-embroidery instead of paint or marker; add interest and dimension with ribbon-embroidery leaves and flowers.

Padded Shapes

Cut a piece of cardboard, mat board or tag board into the desired size and shape; round corners to make covering easier.

Cut a piece of quilt batting the same size as the cardboard shape; glue batting to one side of cardboard. Cut fabric with transfer design 2" larger than cardboard shape, centering design; wrap over batting, smoothing corners and tacking edges in place on cardboard side with dots of glue. Trim excess fabric. Embellish and glue to surface as desired.

Special Thanks to Our Designers

Drawings by our talented designers are listed by page number below:

June Fiechter 10, 12, 21, 22, 31, 39, 40, 51, 52, 56, 58, 60, 62, 70, 73, 88, 103, 106

Kathleen Hurley 11, 15, 16, 17, 18, 19, 20, 34, 36, 37, 54, 59

Samantha McNesby 49, 65, 93, 96, 99, 102, 105, 110, 117

Darlene Polachic 9, 13, 69, 111

Vicki Schreiner 14, 32, 33, 35, 38, 50, 55, 57, 84, 92, 107, 108, 114

Barbara Sestok 23, 24, 25, 26, 27, 28, 29, 30, 41, 42, 43, 44, 45, 46, 47, 48, 53, 61, 63, 64, 66, 67, 68, 71, 72, 74, 75, 76, 77, 78, 79, 80, 81, 82, 83, 85, 86, 87, 89, 90, 91, 94, 95, 97, 98, 100, 101, 104, 109, 112, 113, 115, 116, 118, 119, 120

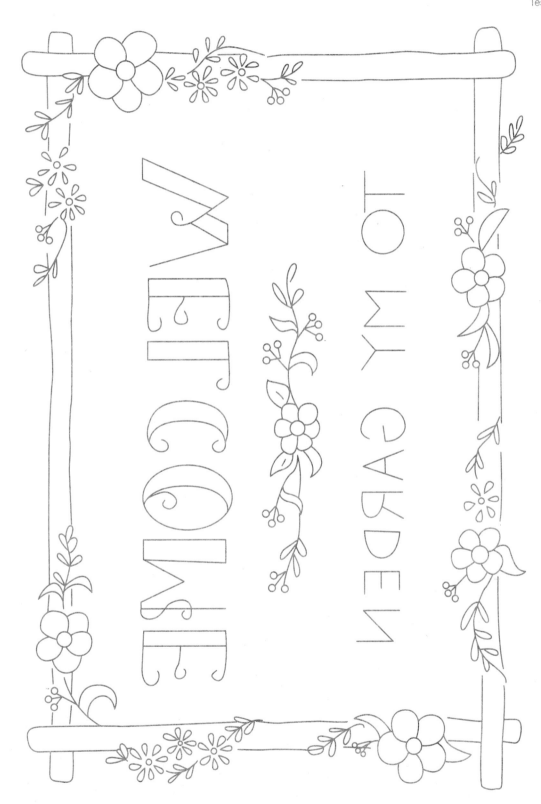

WELCOME TO MY GARDEN

May all your weeds be wildflowers

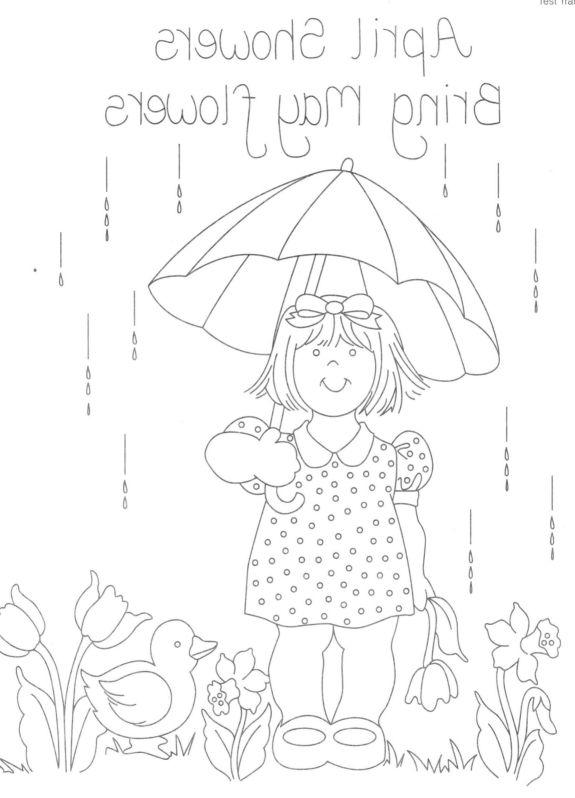

BWH©

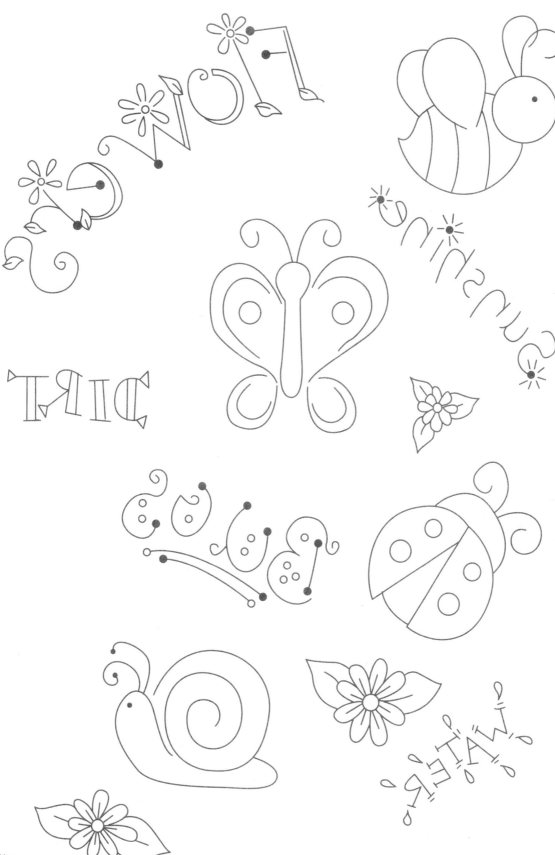

BWH©

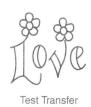
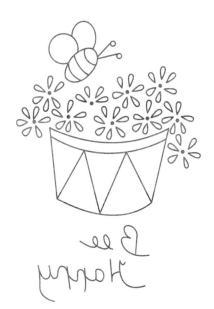

Bee
Happy

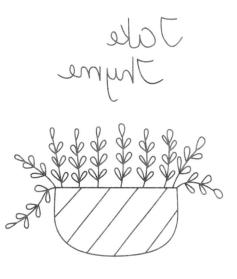

Tôte
Thyme

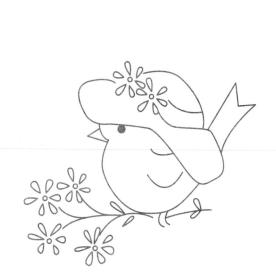

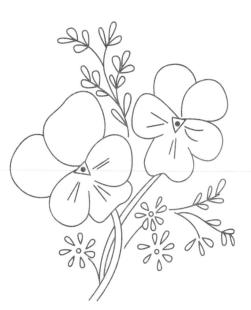

13

Test Transfer

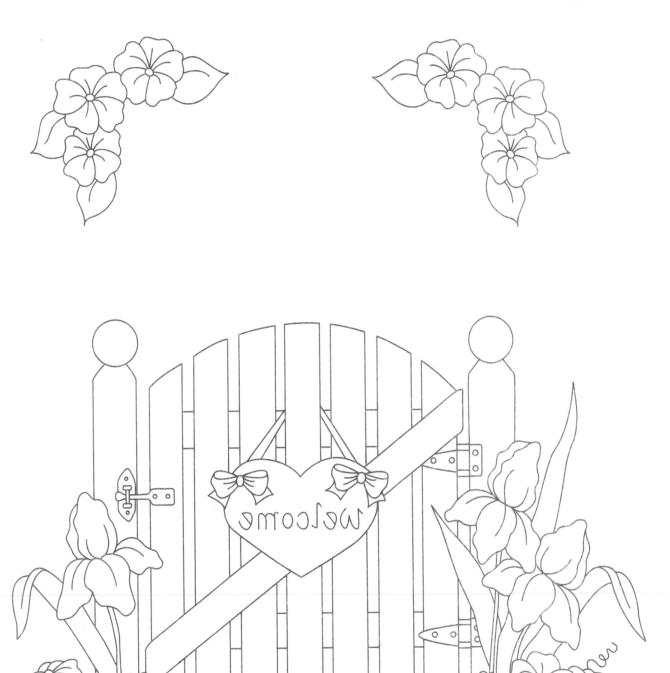

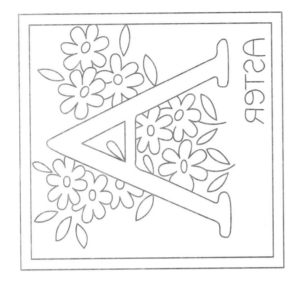

ASTER

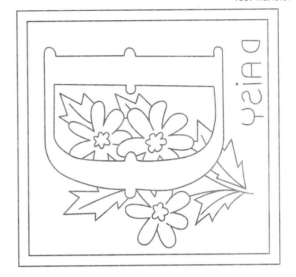

DAISY

BUTTERCUP

ECTANINE

COLUMBINE

FAIRY MAID

Love

Test Transfer

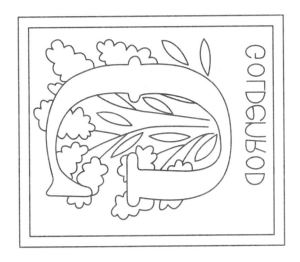

Gooseberry

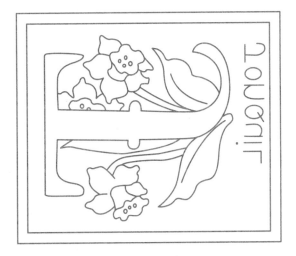

Jonquil

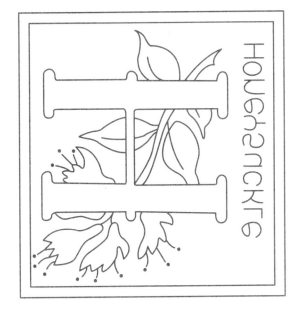

Honeysuckle

Knotweed

Ivy

Lily of the Valley

Test Transfer

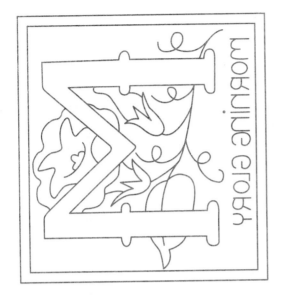
MORNING GLORY

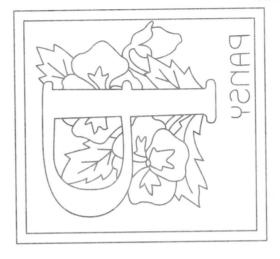
PANSY

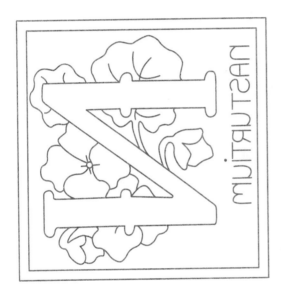
NASTURTIUM

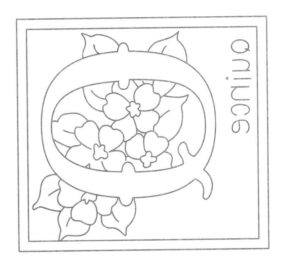
QUINCE

OLEANDER

ROSE

©HWB

Love

Test Transfer

sunflower

violet

tulip

wood lily

uvularia

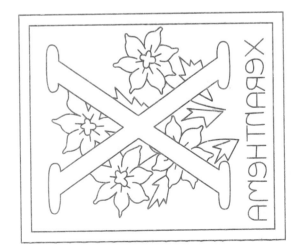

Xeranthemum

©HWB

Test Transfer

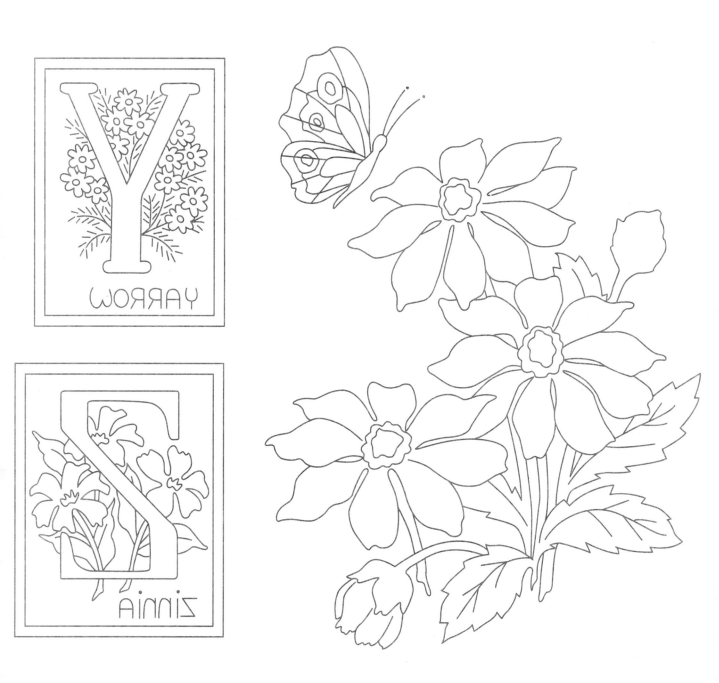

YARROW

ZINNIA

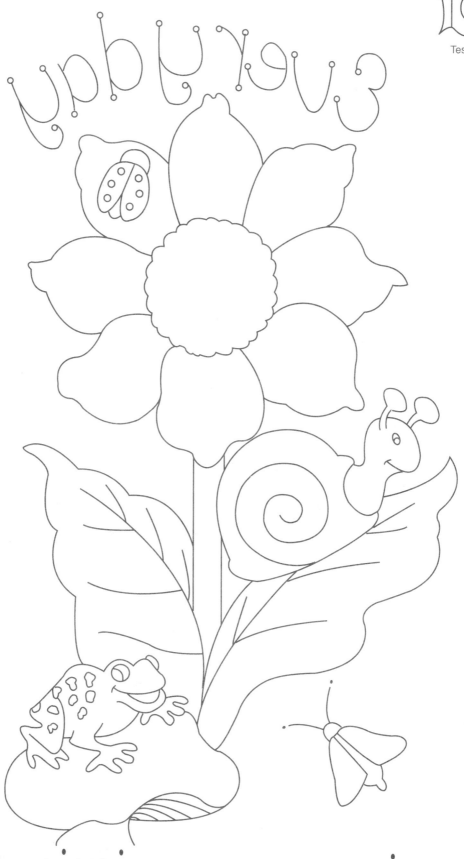

Every day

is a new Beginning!

20

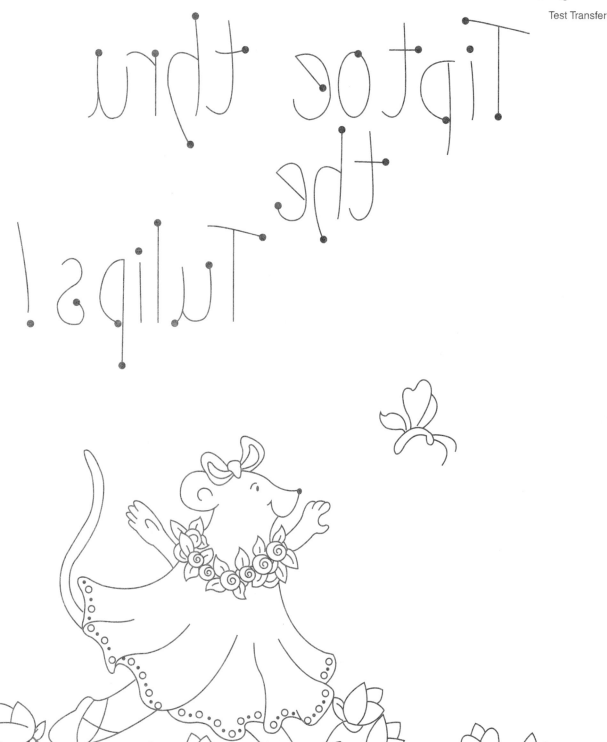

Tiptoe thru the Tulips!

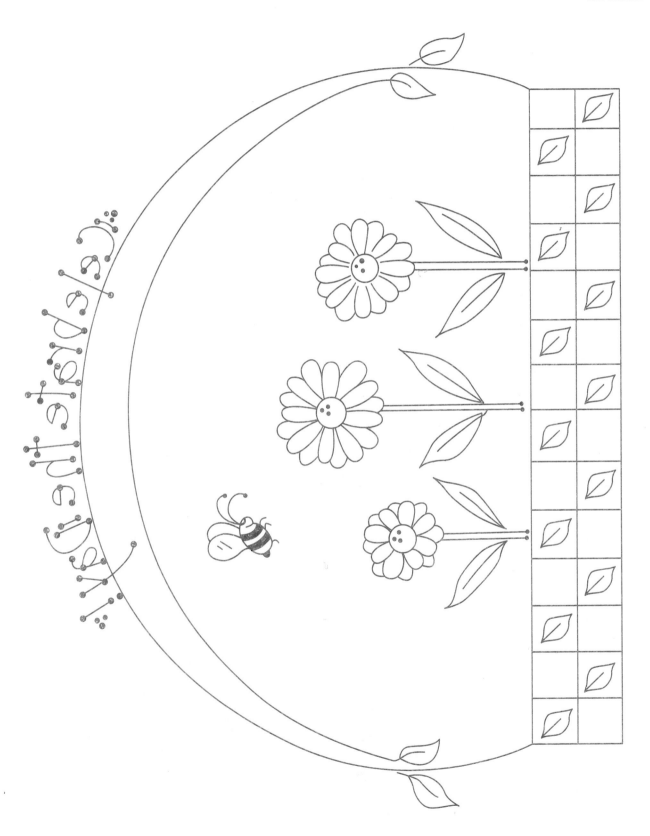

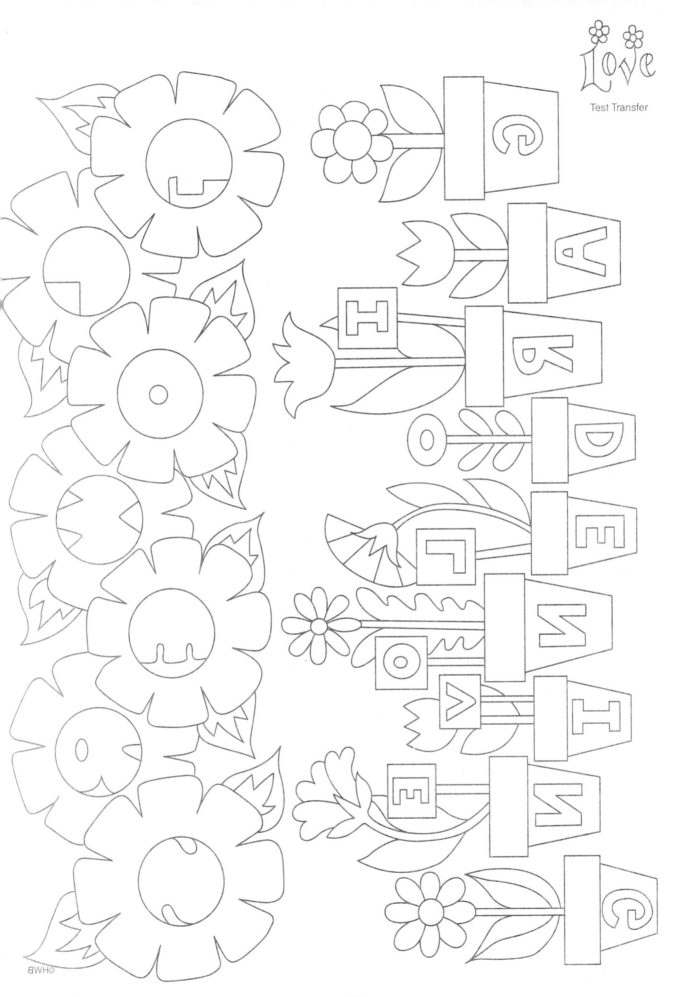

Test Transfer

23

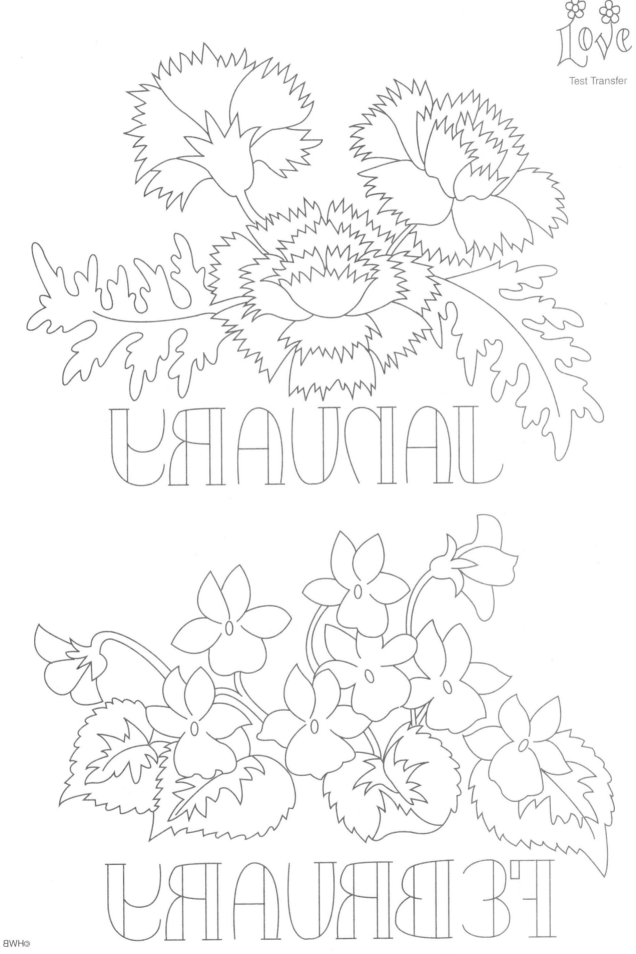

Love
Test Transfer

JANUARY

FEBRUARY

©HWB

24

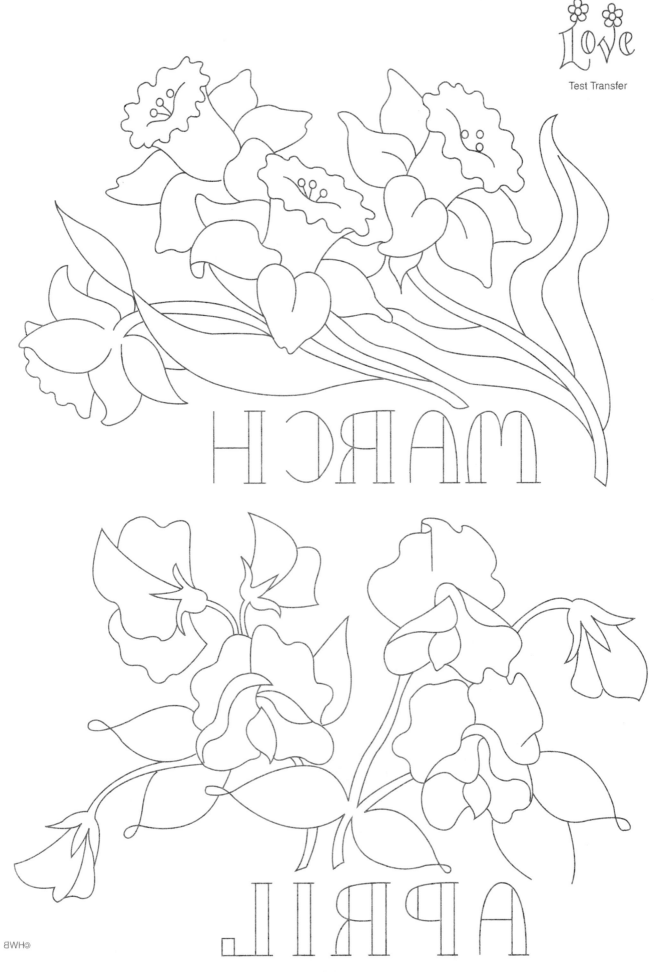

Love
Test Transfer

MARCH

APRIL

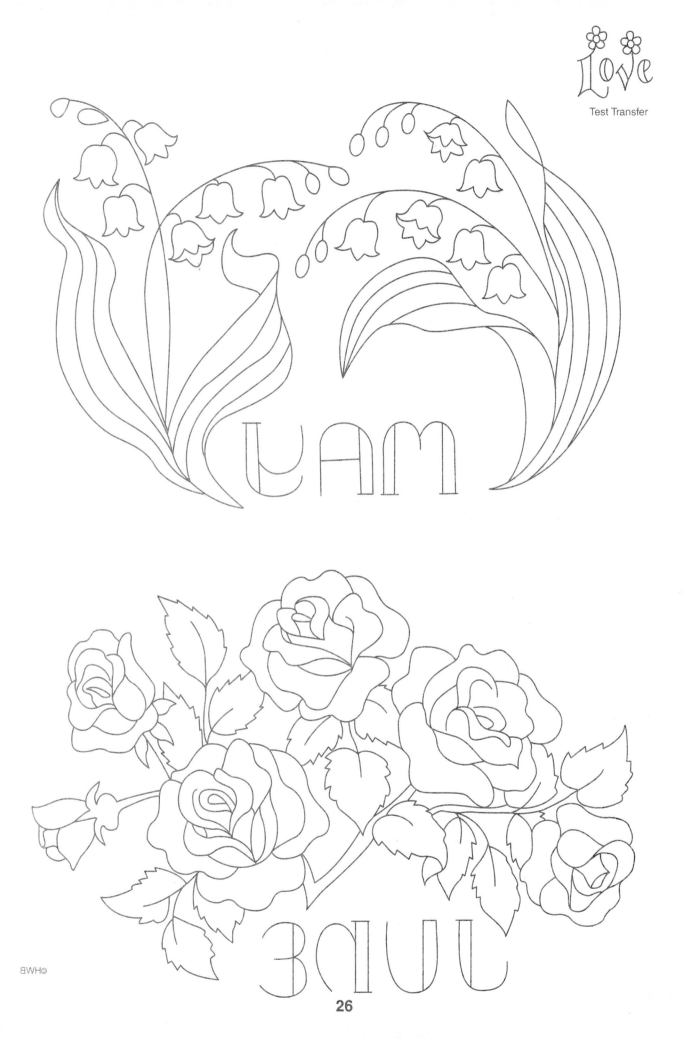

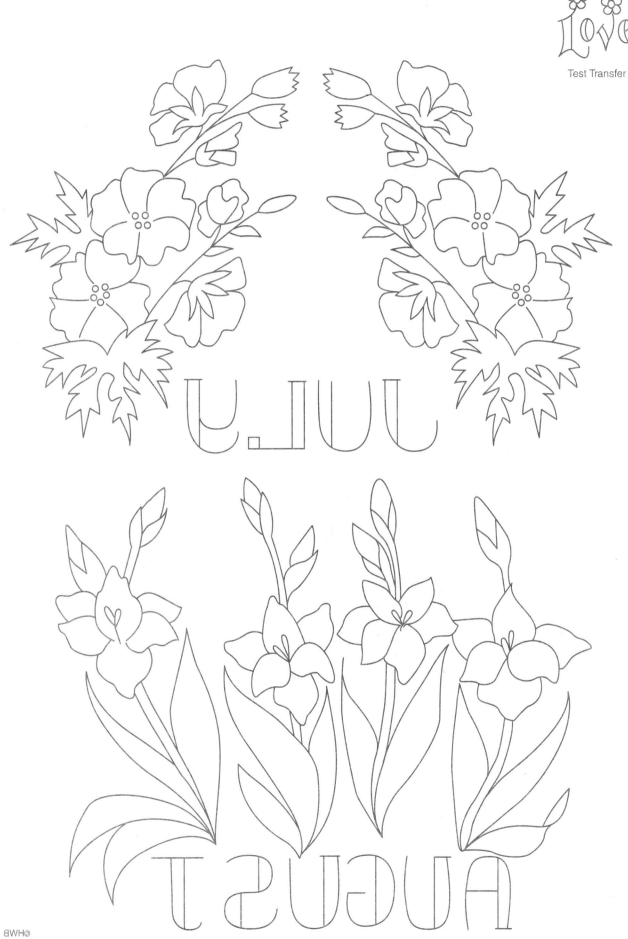

Love
Test Transfer

JULY

AUGUST

©HWB

27

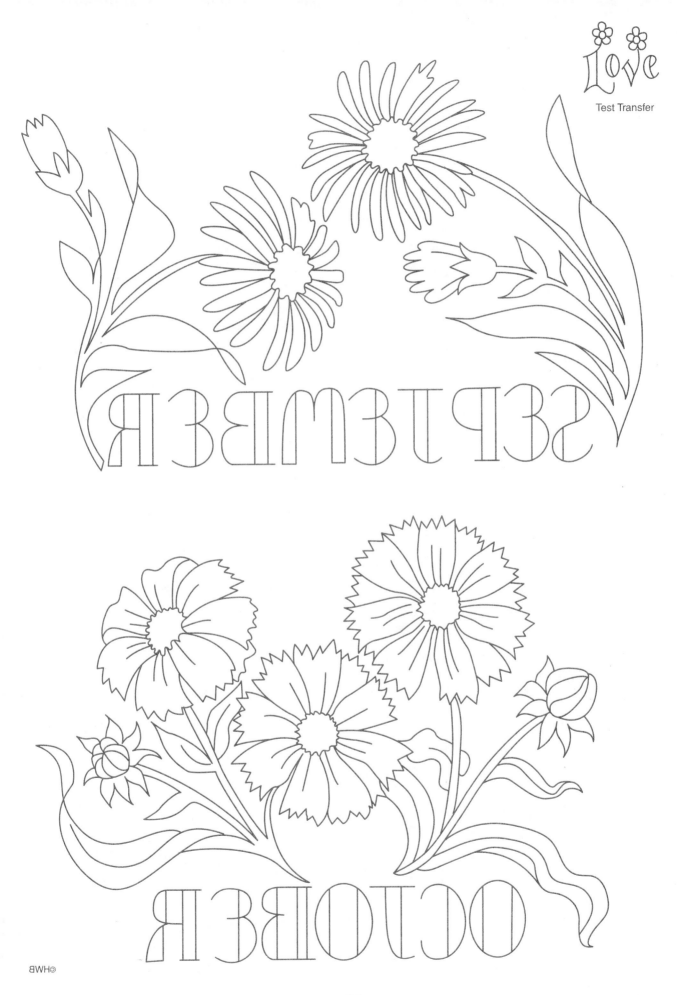

SEPTEMBER

OCTOBER

Love
Test Transfer

28

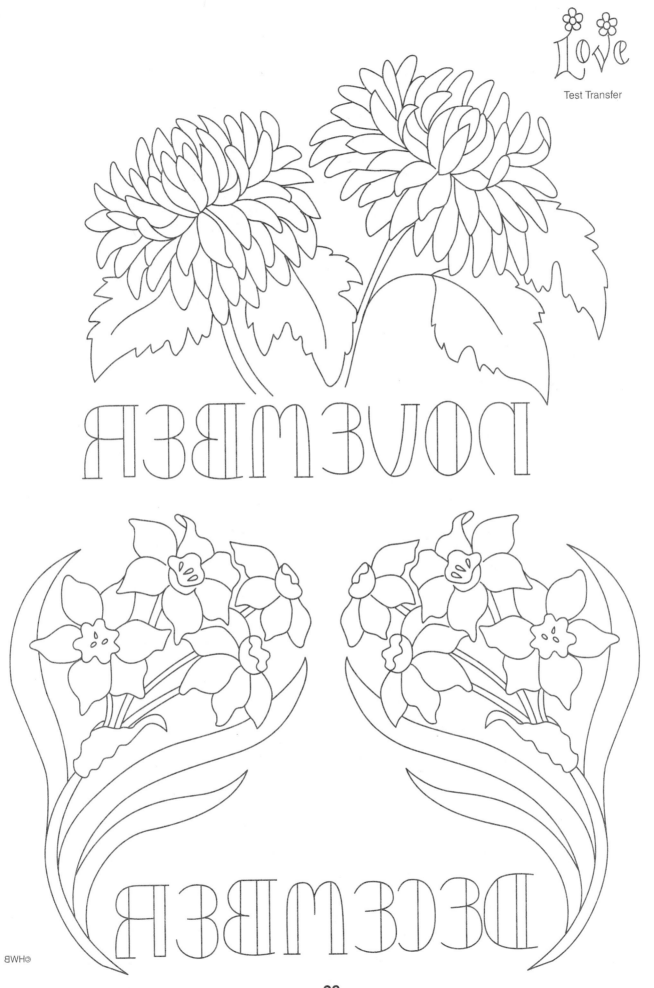

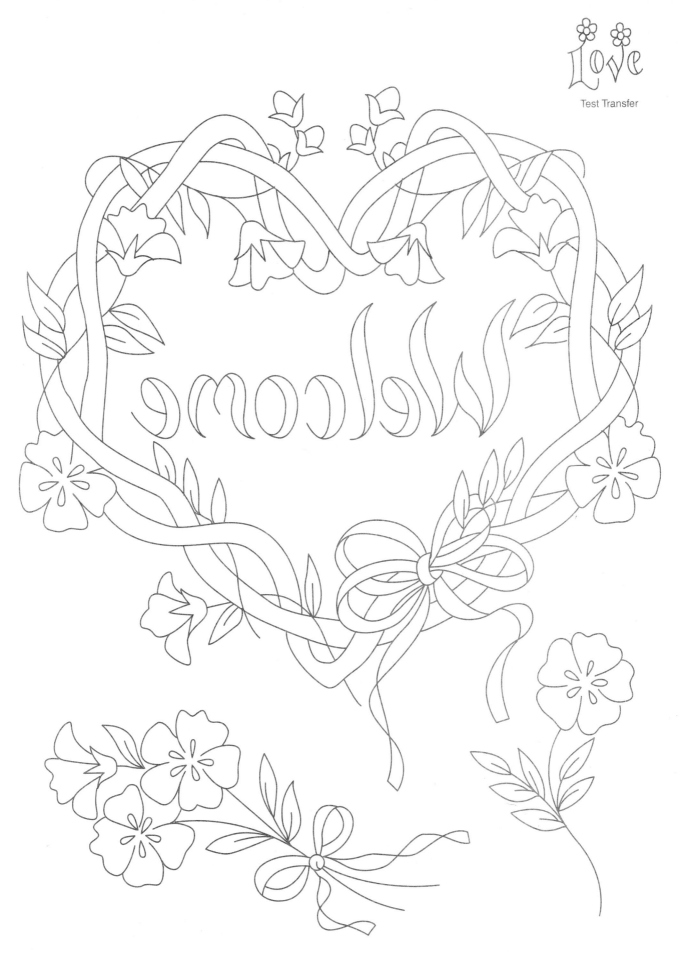

Love

Test Transfer

30

Test Transfer

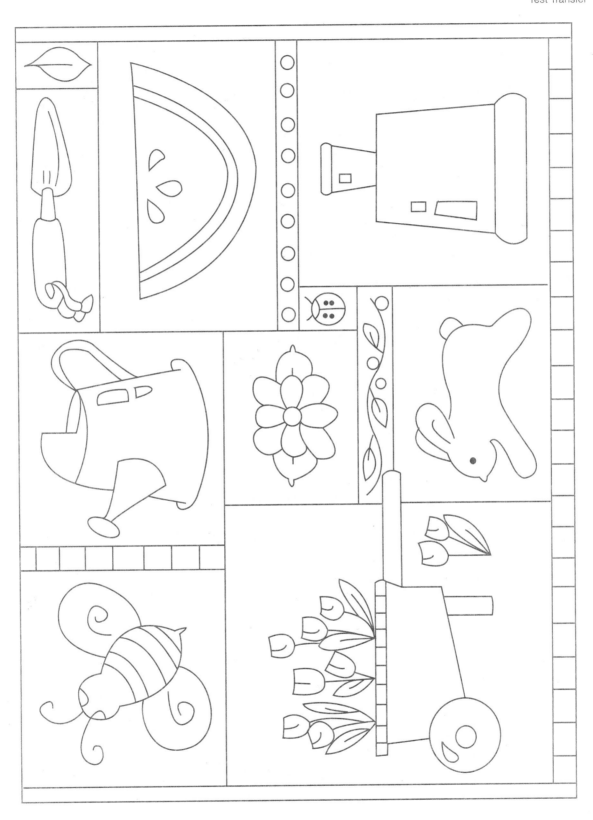

Test Transfer

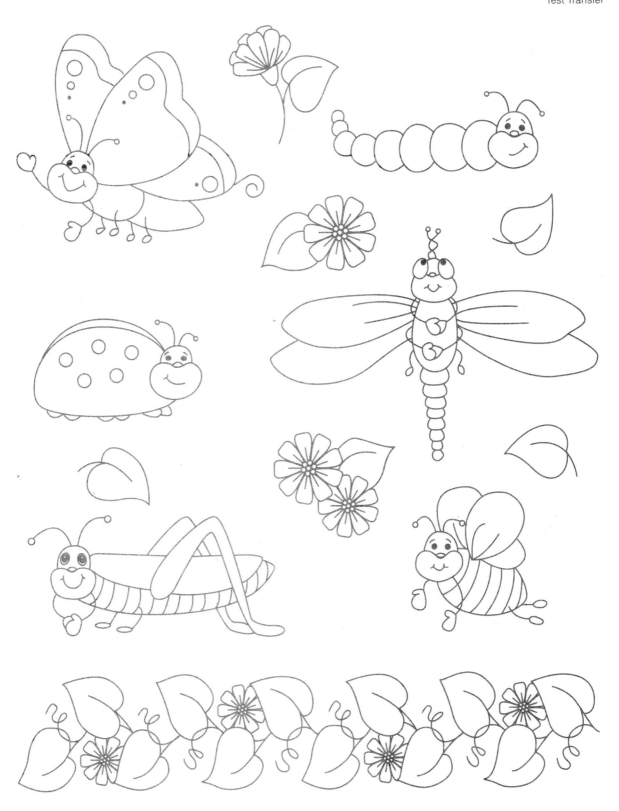

Test Transfer

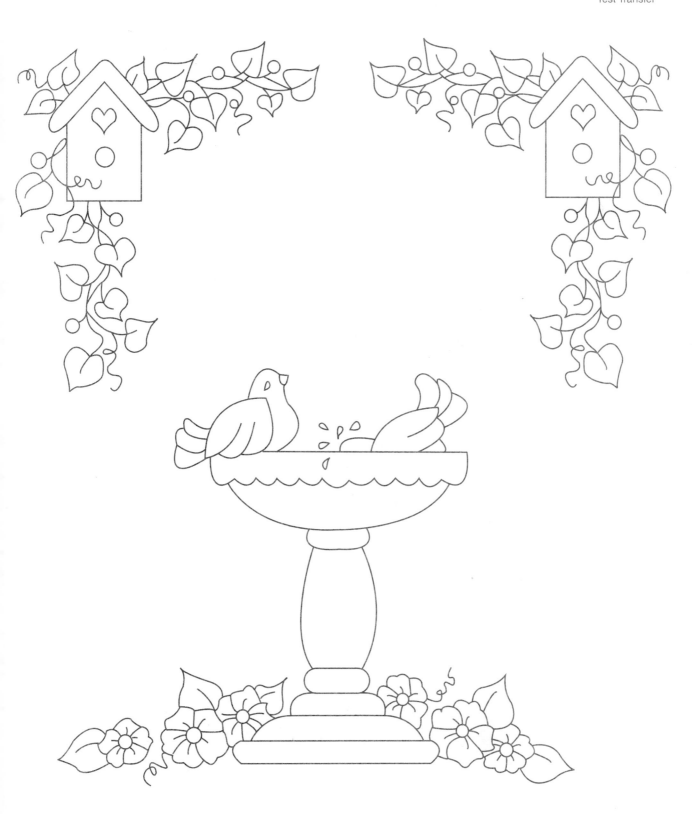

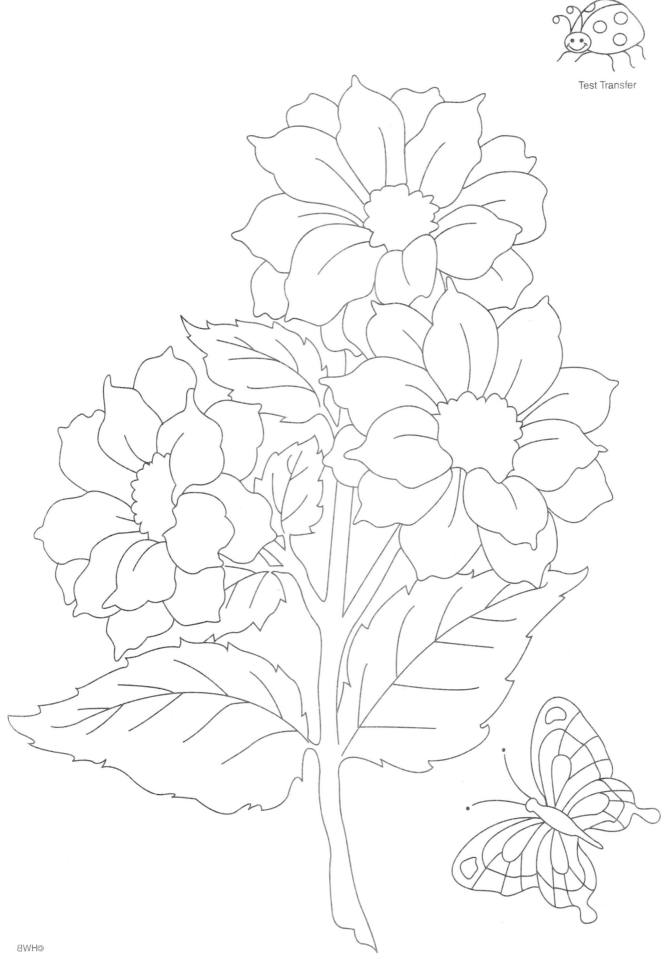

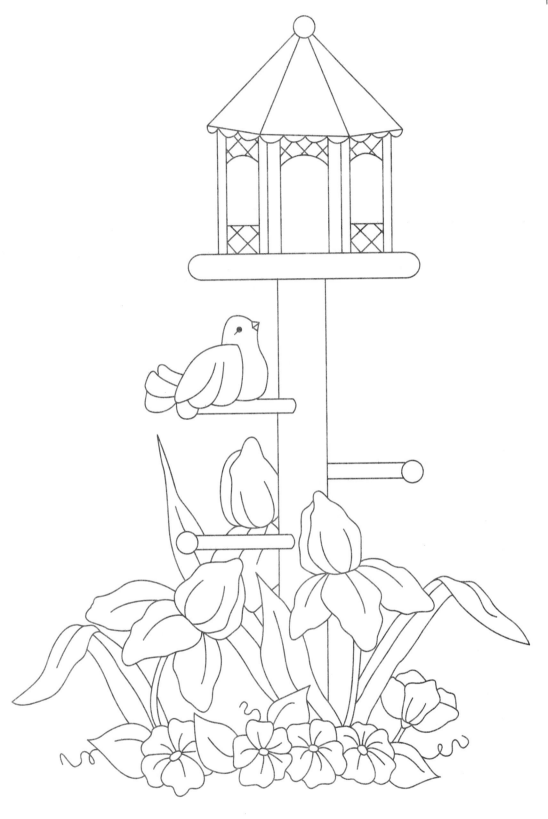

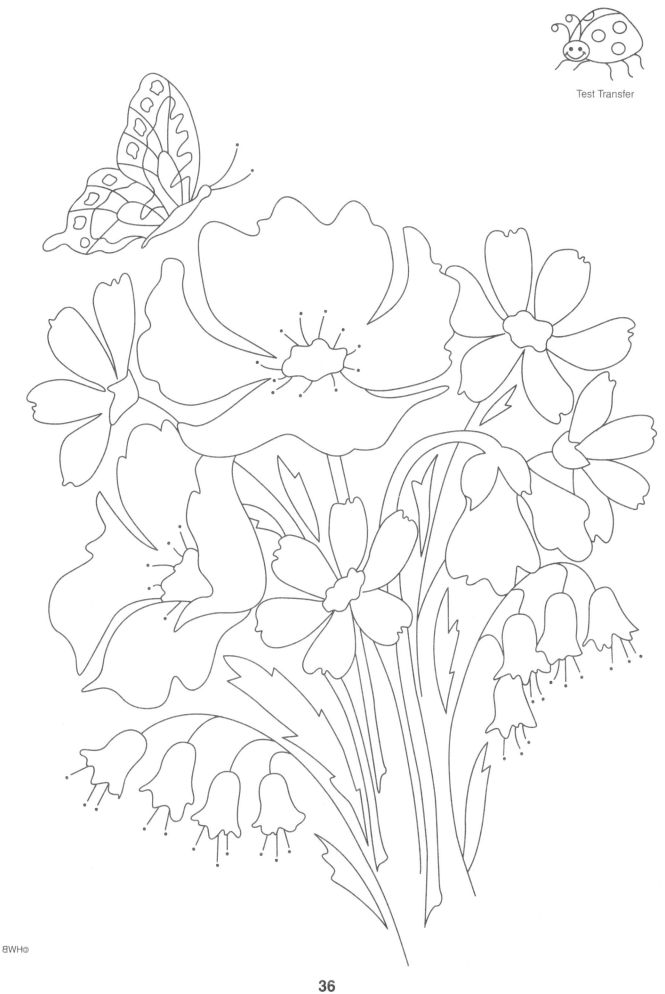

Test Transfer

BWH©

36

Test Transfer

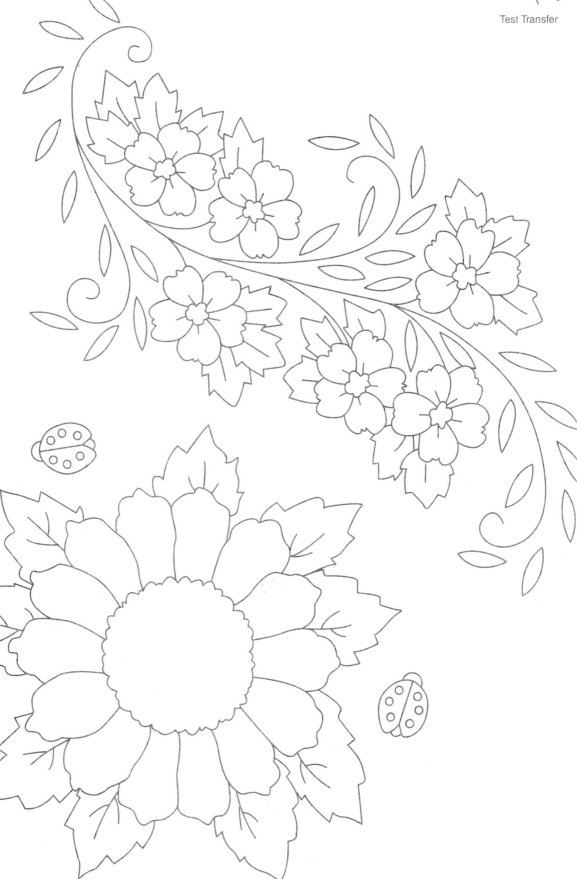

©BWH

37

Test Transfer

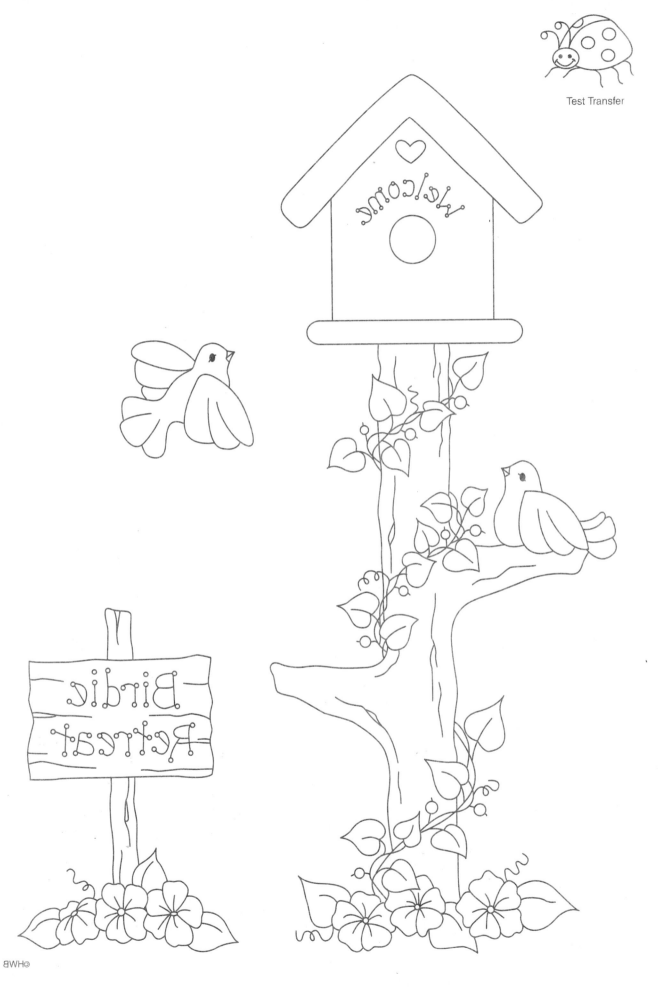

Test Transfer

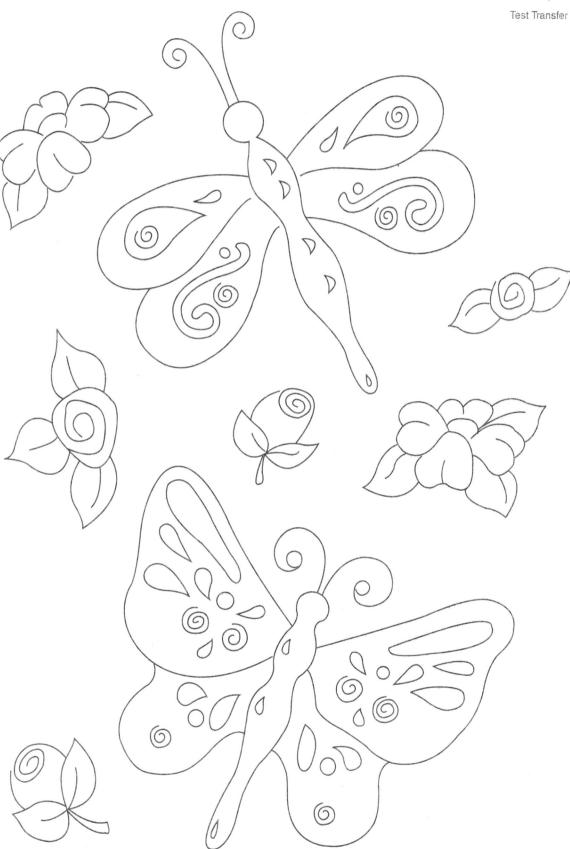

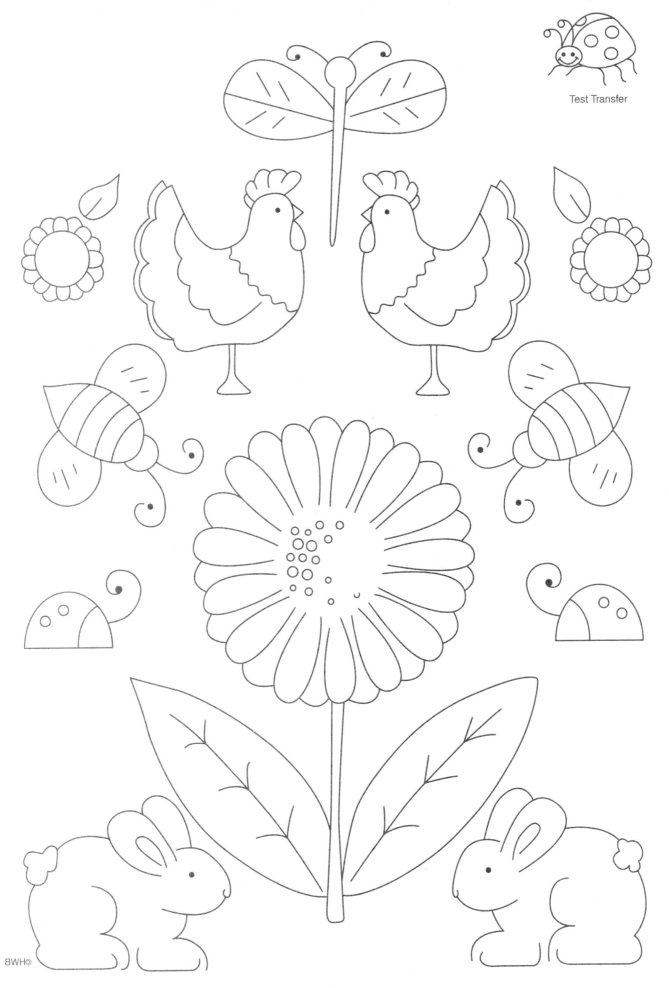

Test Transfer

©HWB

40

Test Transfer

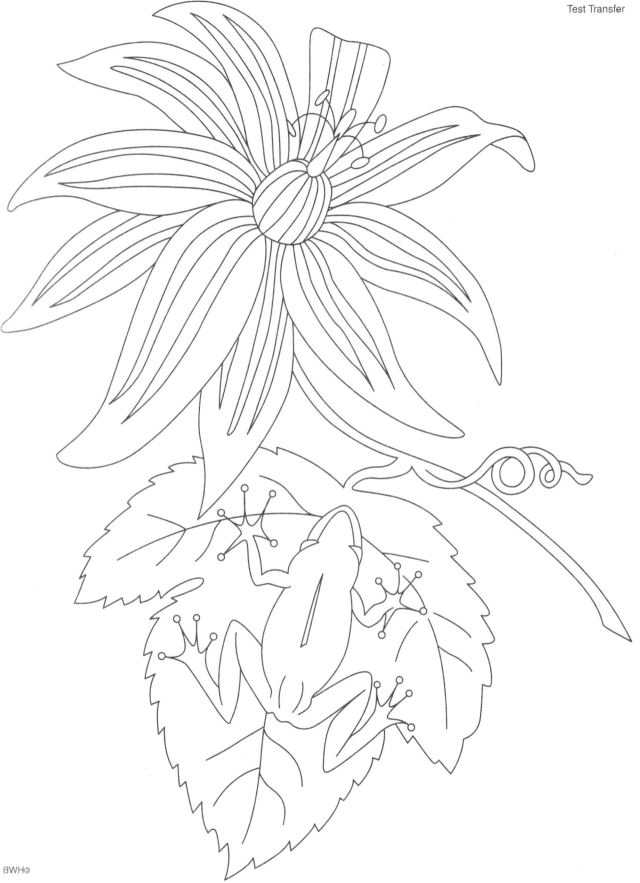

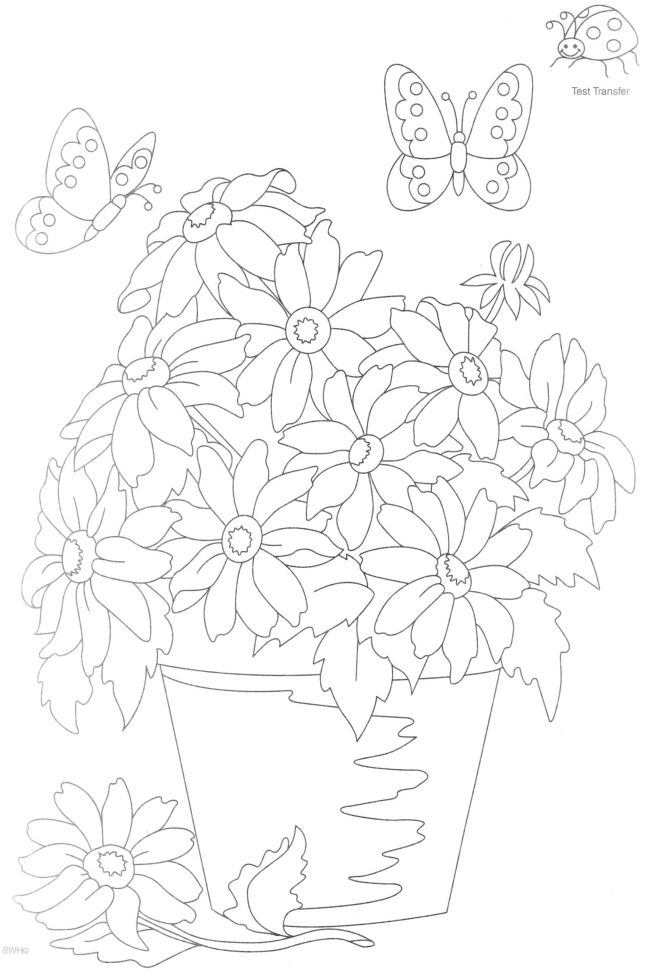

Test Transfer

BWH©

42

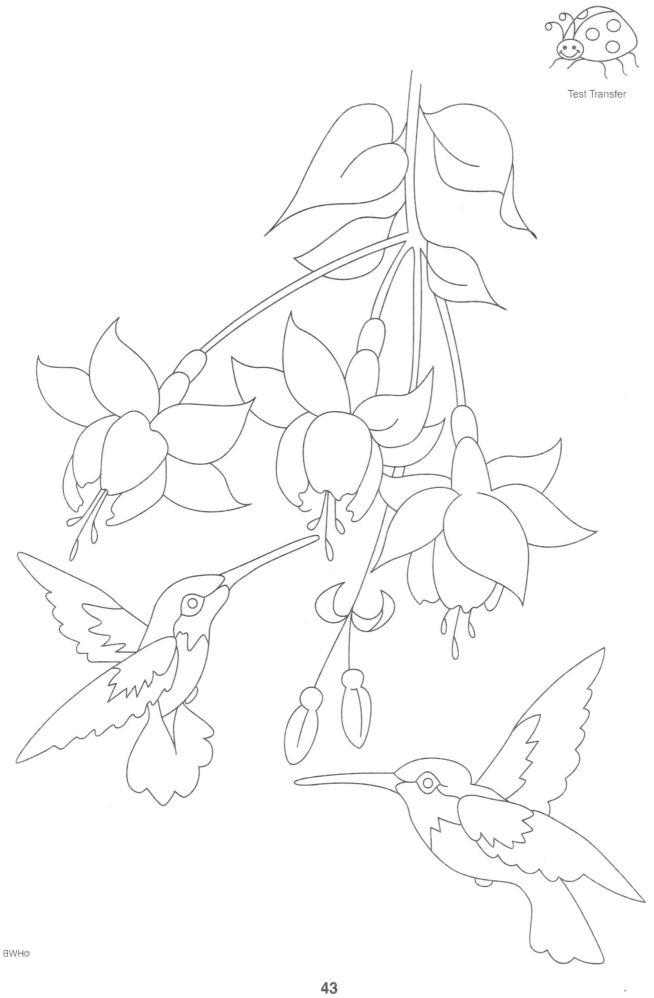

Test Transfer

©HWB

43

Test Transfer

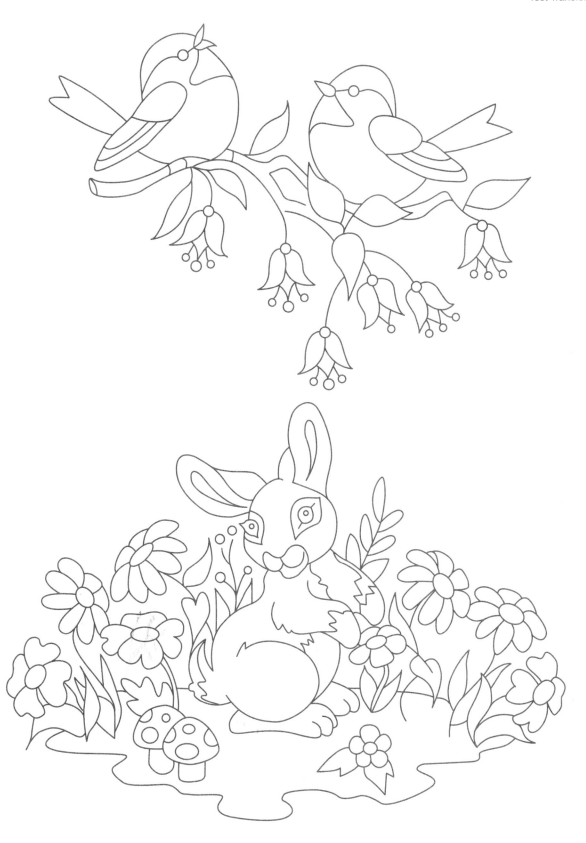

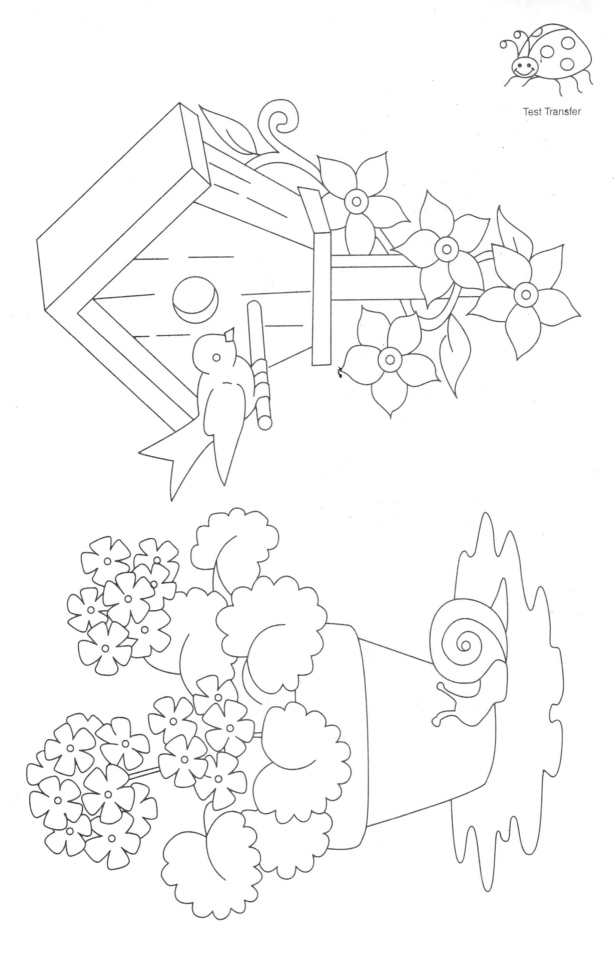

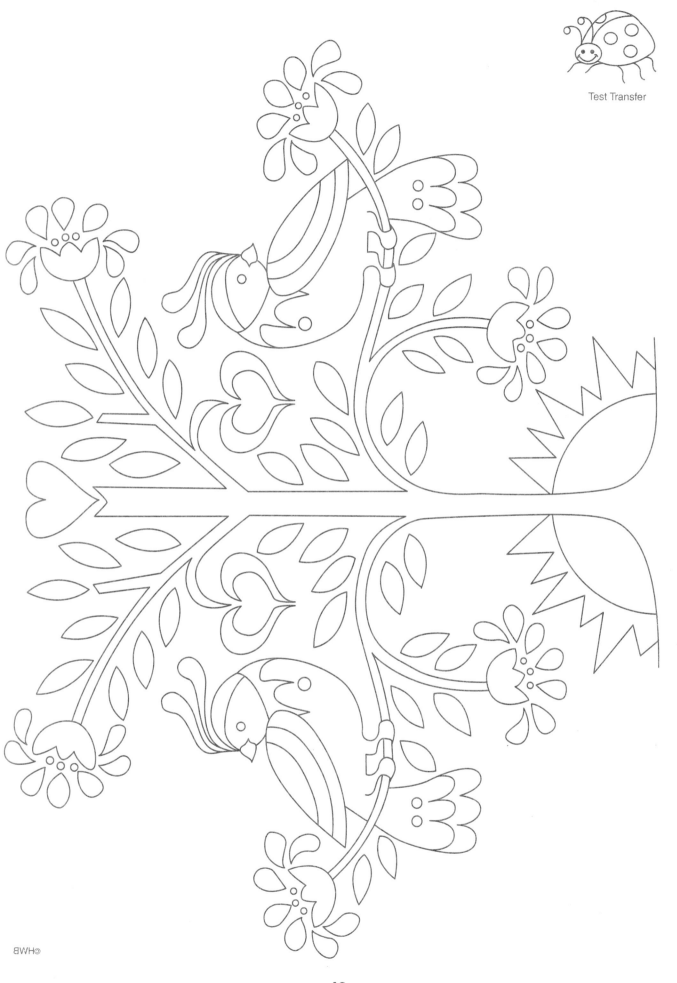

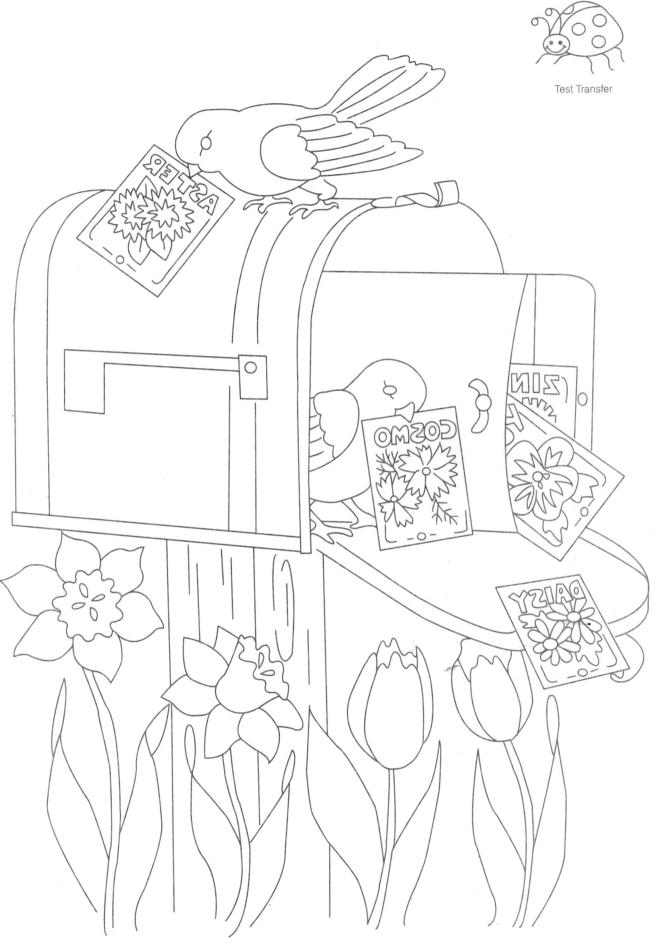

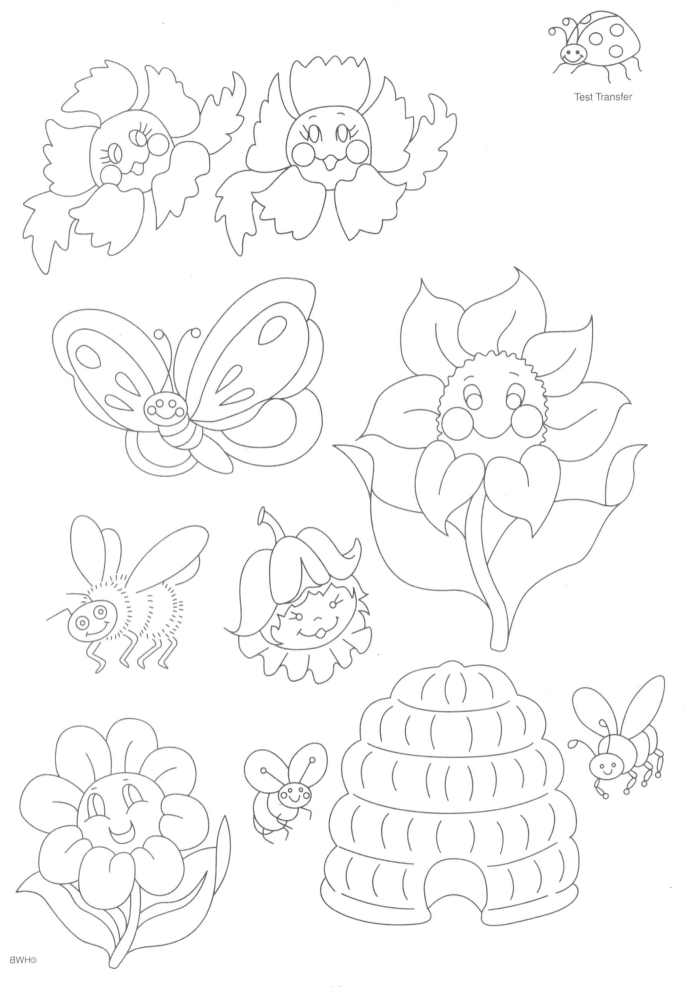

Test Transfer

©HWB

48

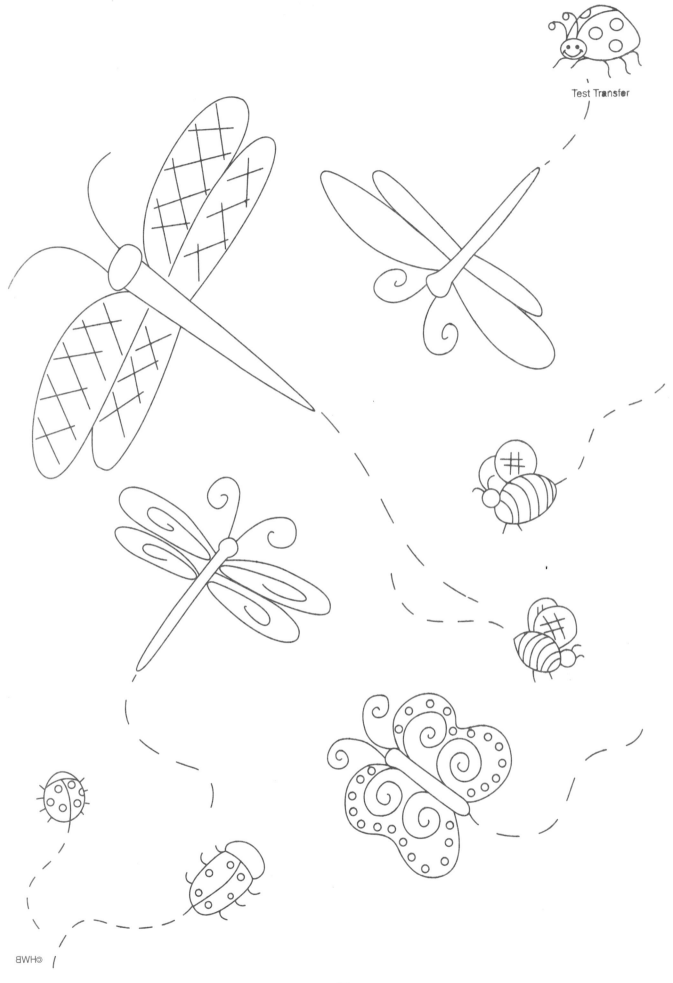

Test Transfer

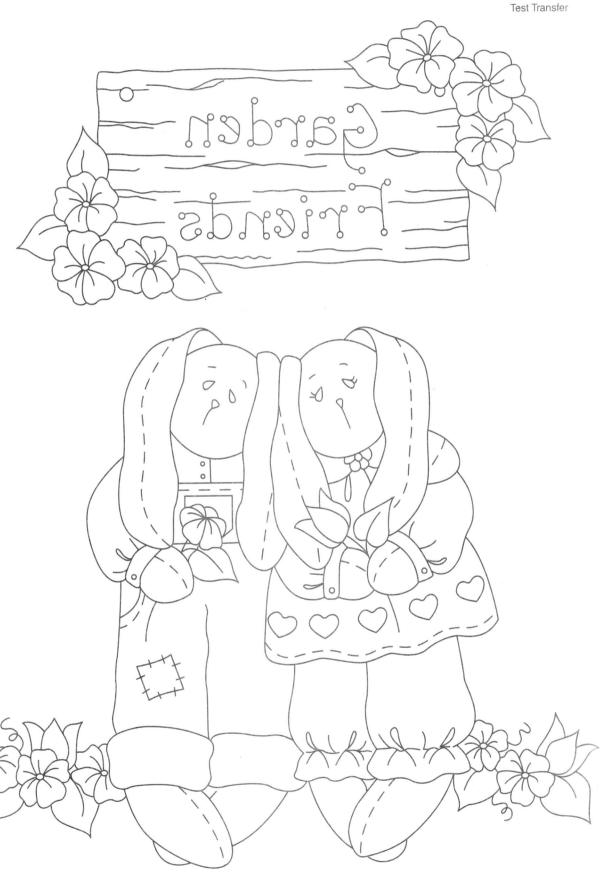

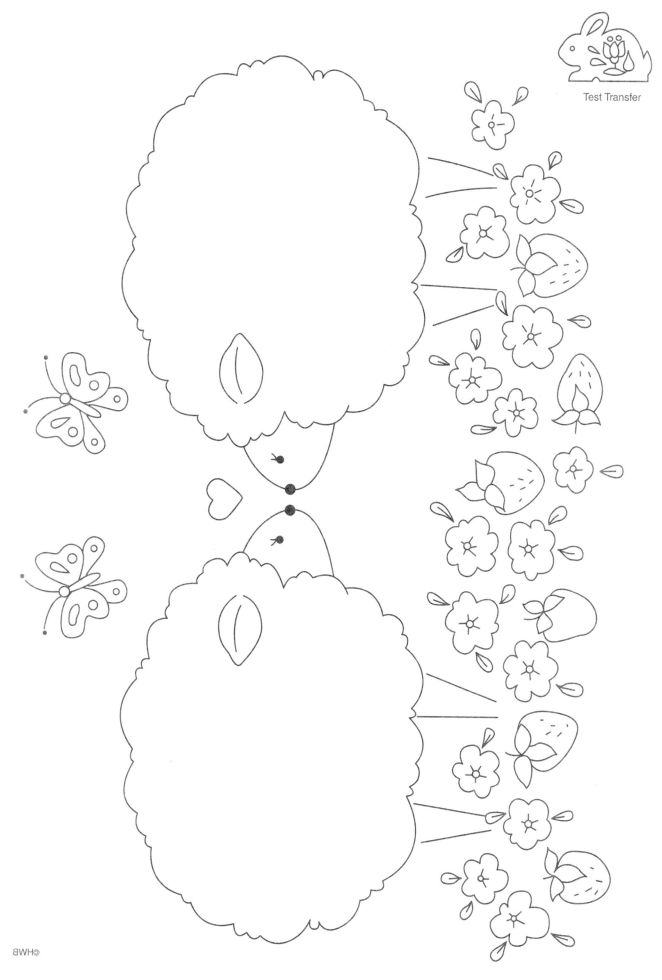

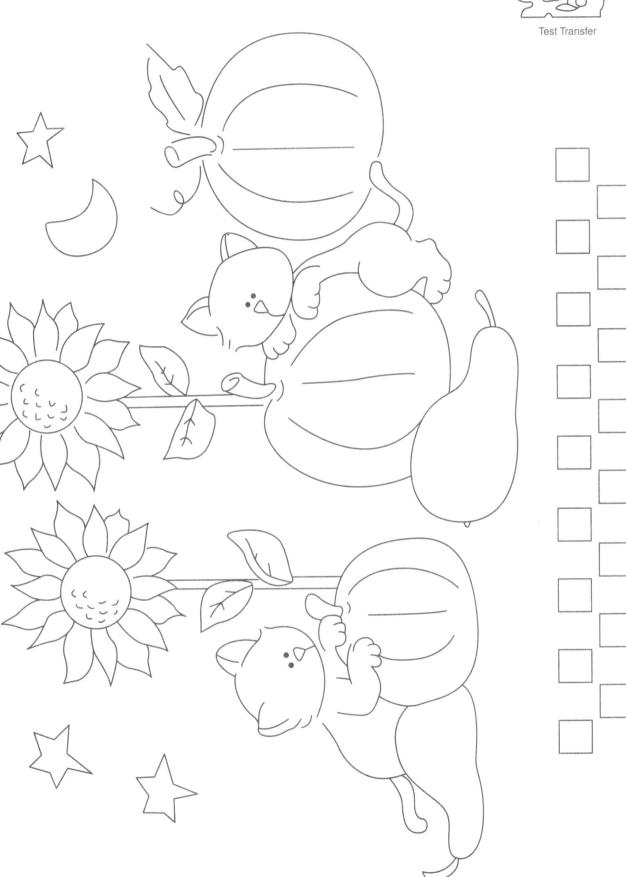

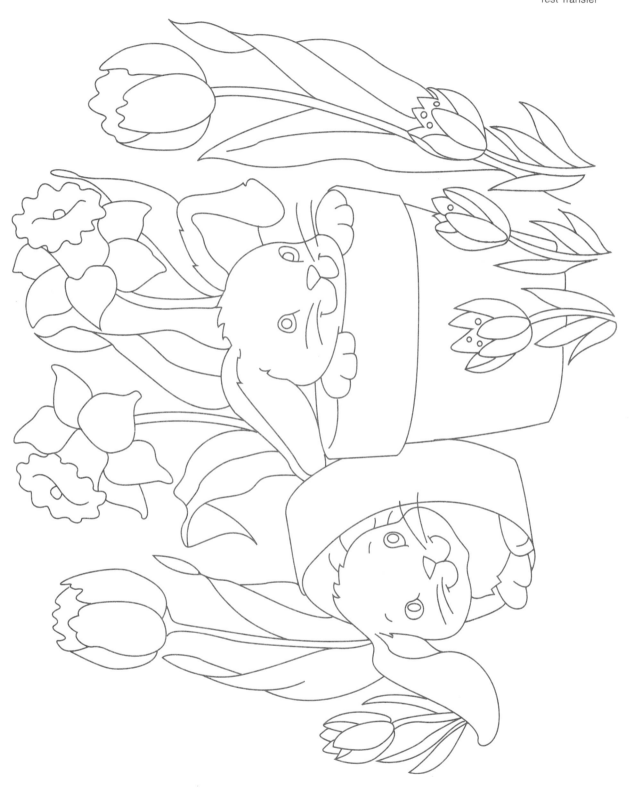

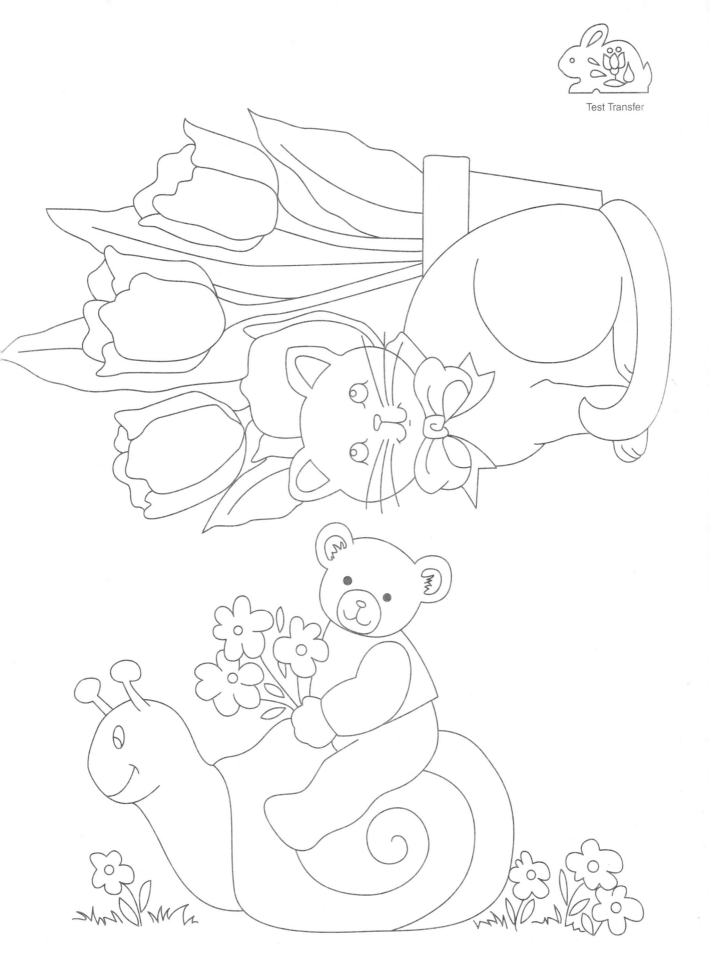

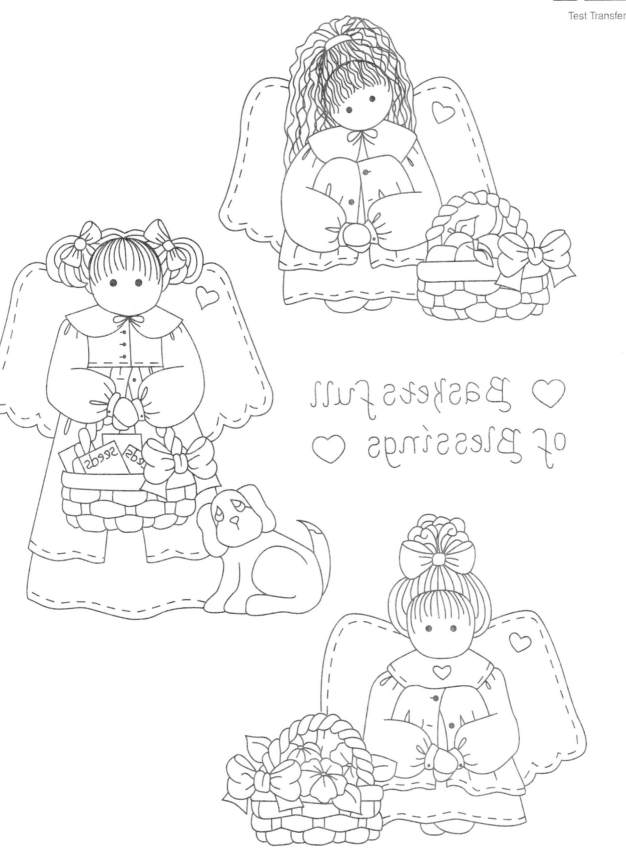

♡ Baskets full
of Blessings ♡

Test Transfer

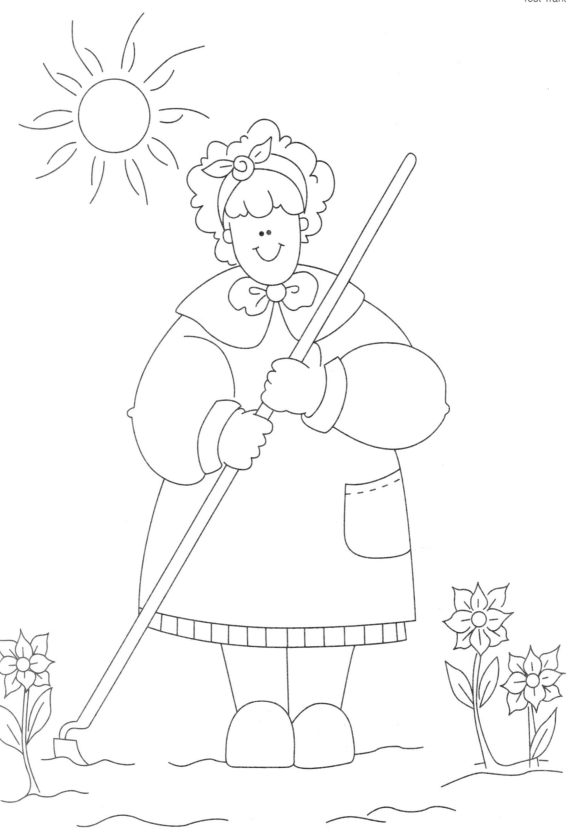

Test Transfer

Test Transfer

©HWB

Test Transfer

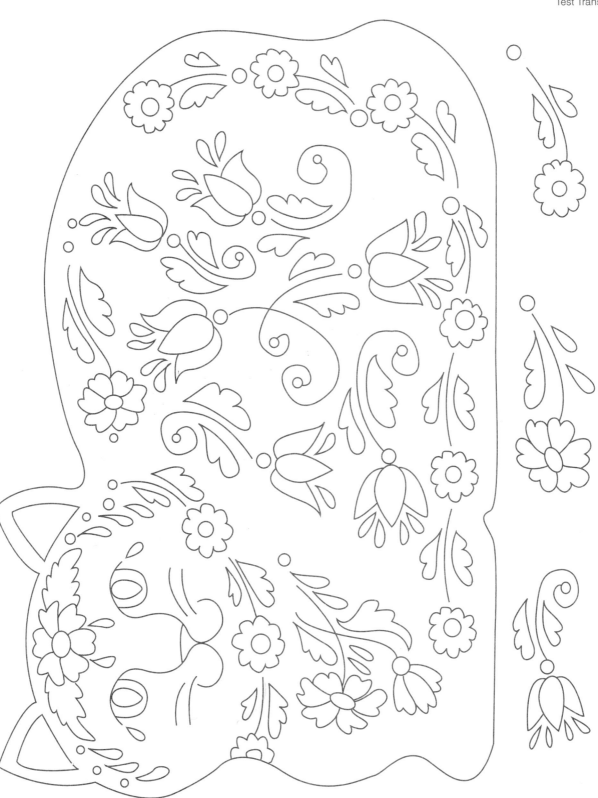

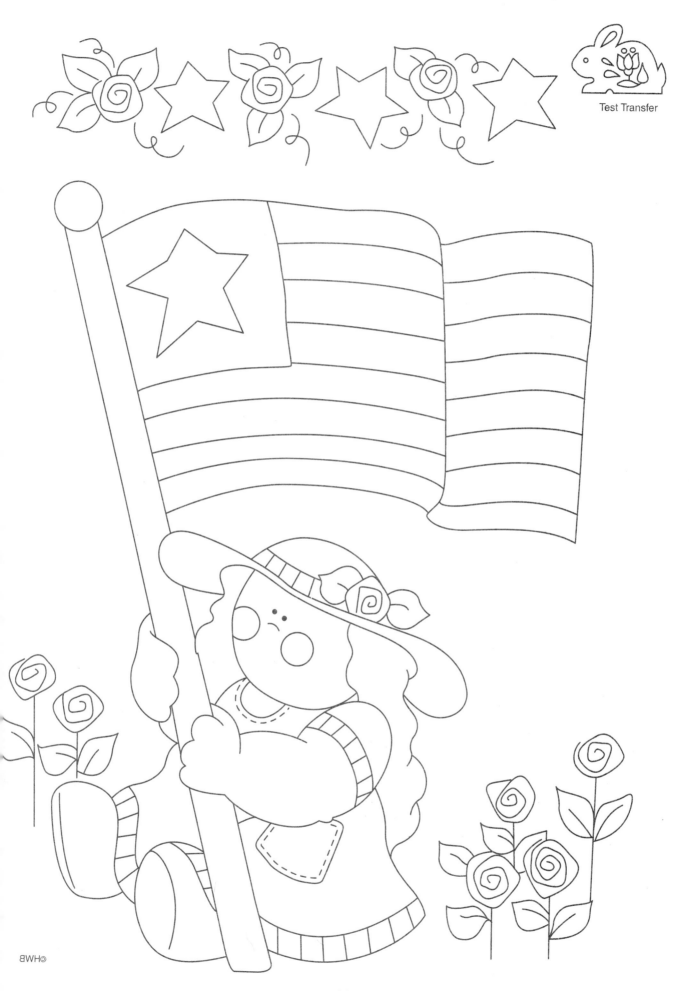

Test Transfer

BWH©

62

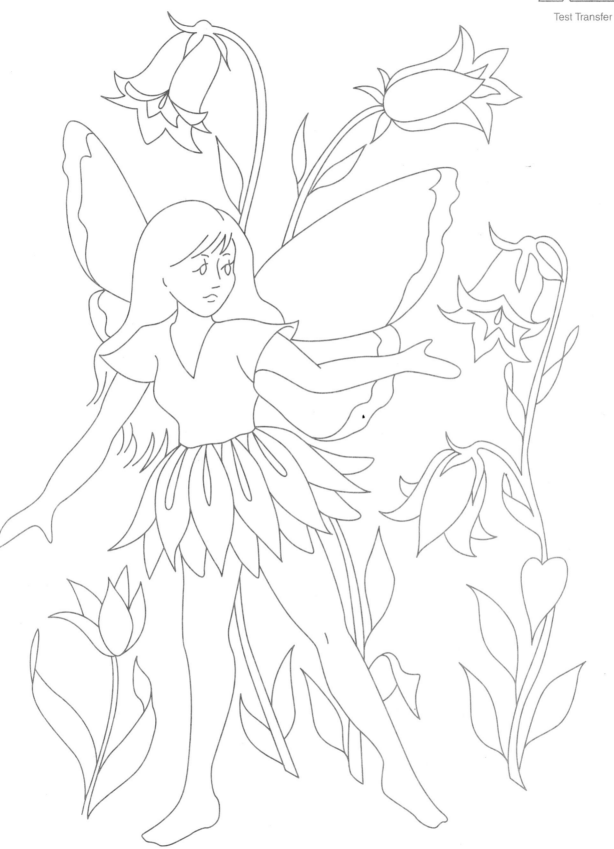

©HWB

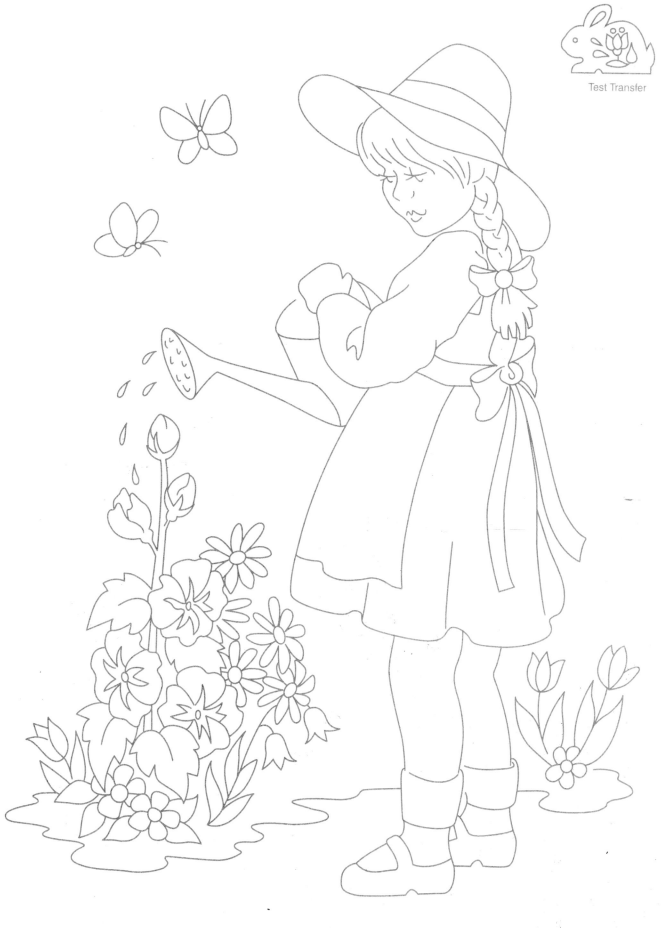

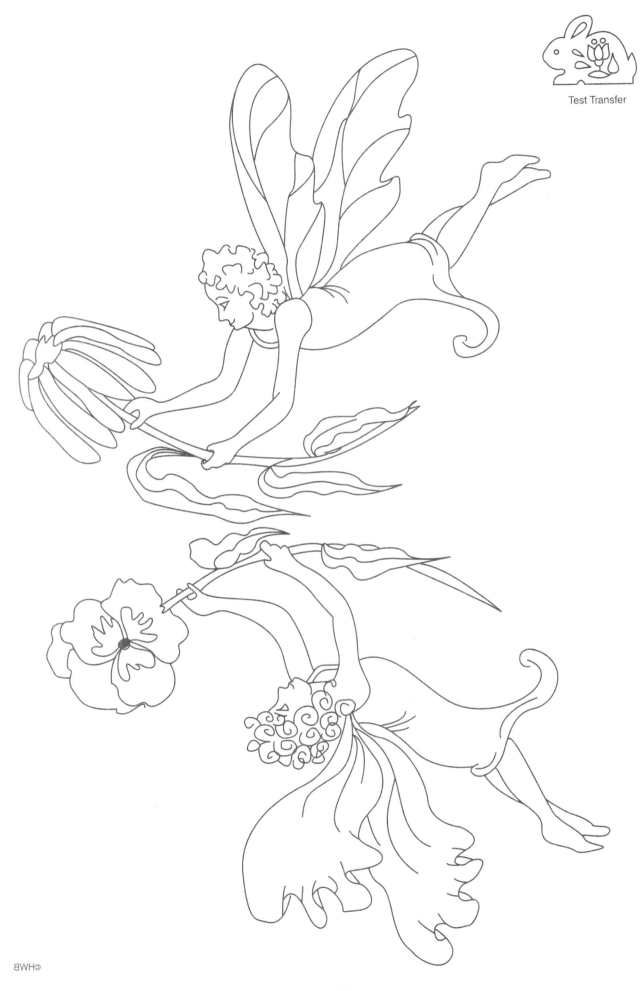

Test Transfer

65

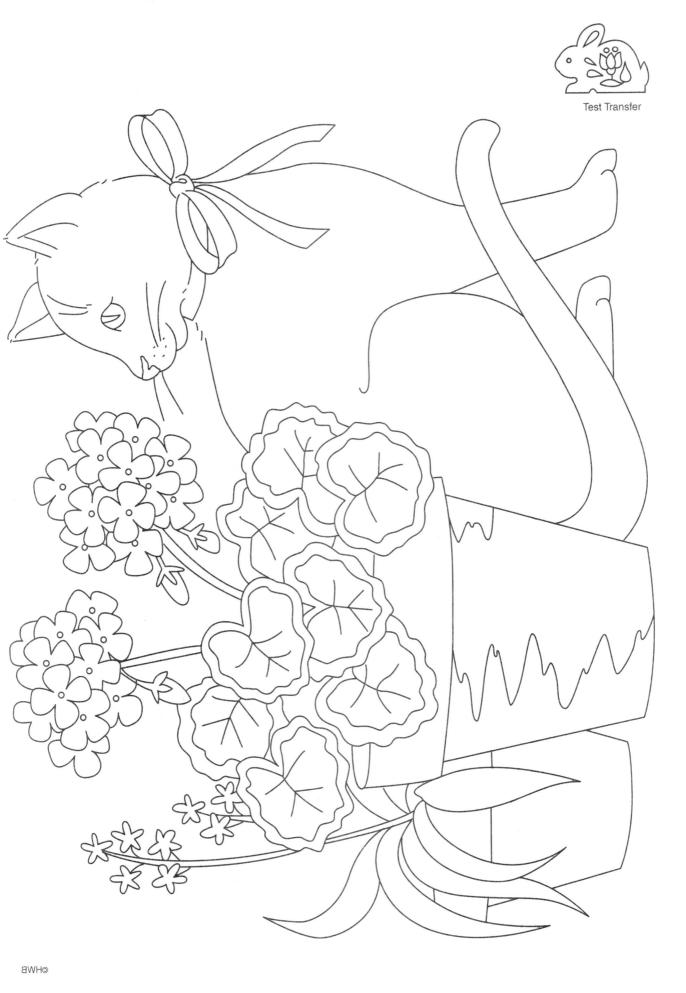

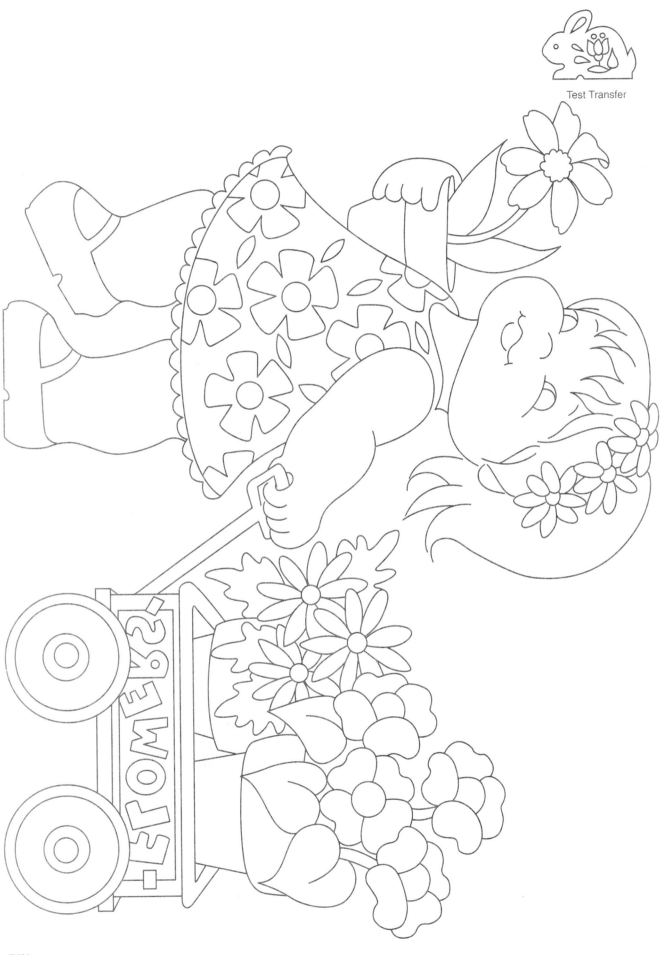

Test Transfer

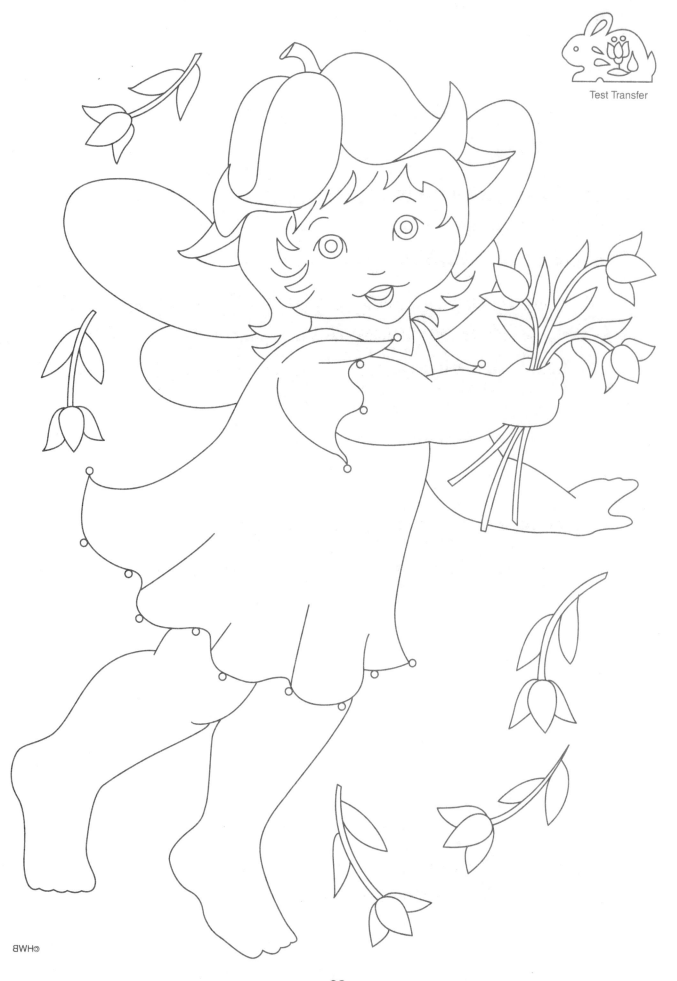

Test Transfer

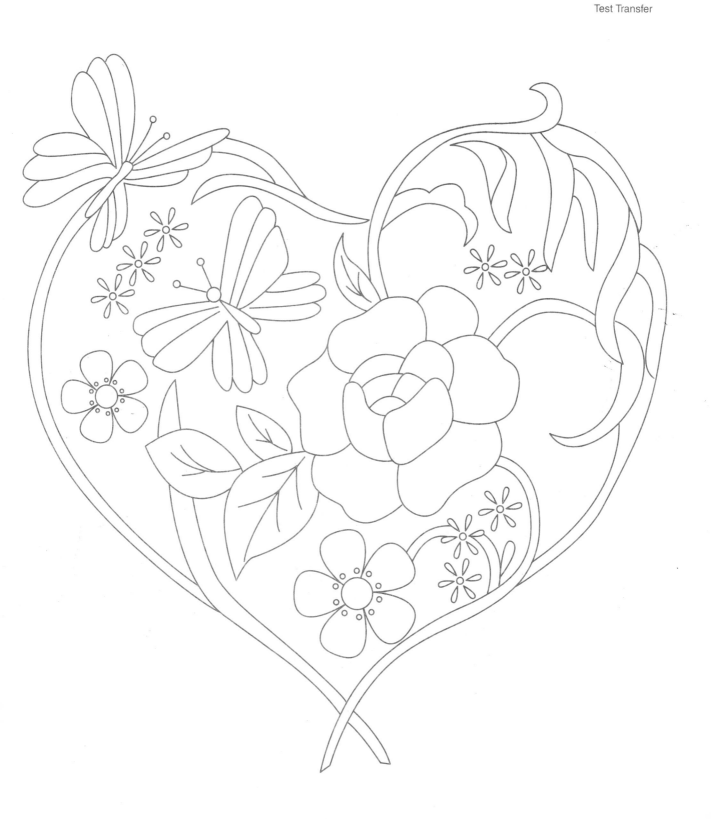

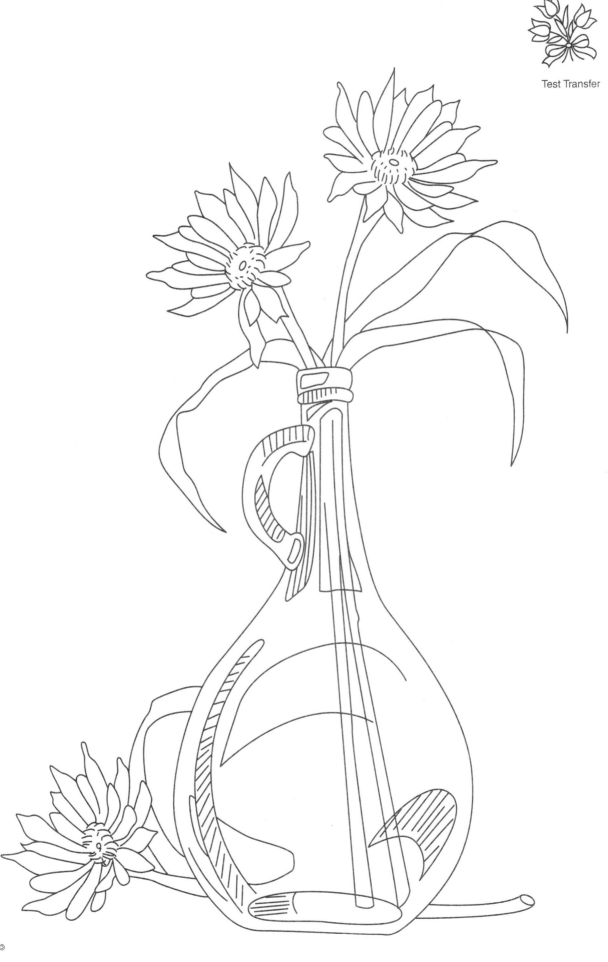

©BWB

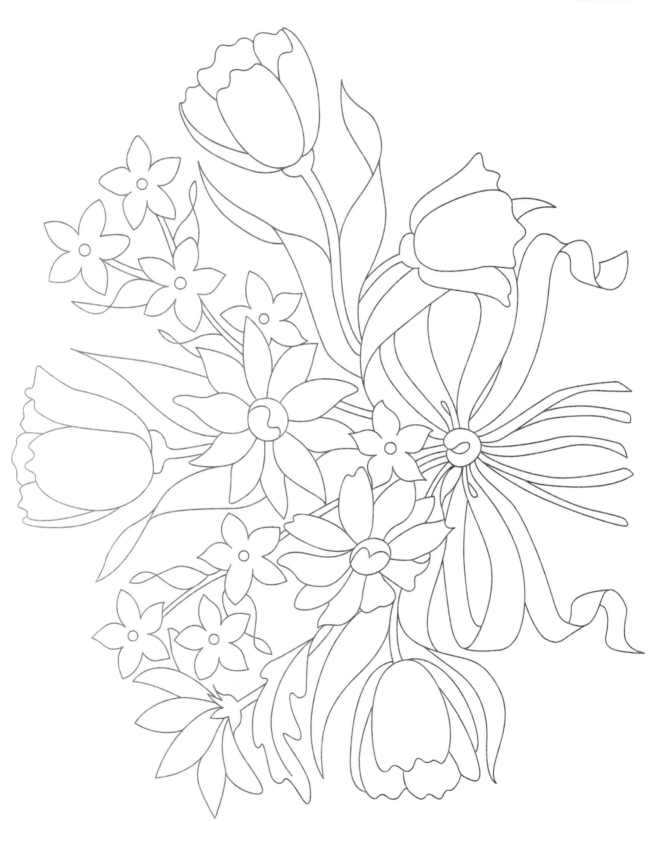

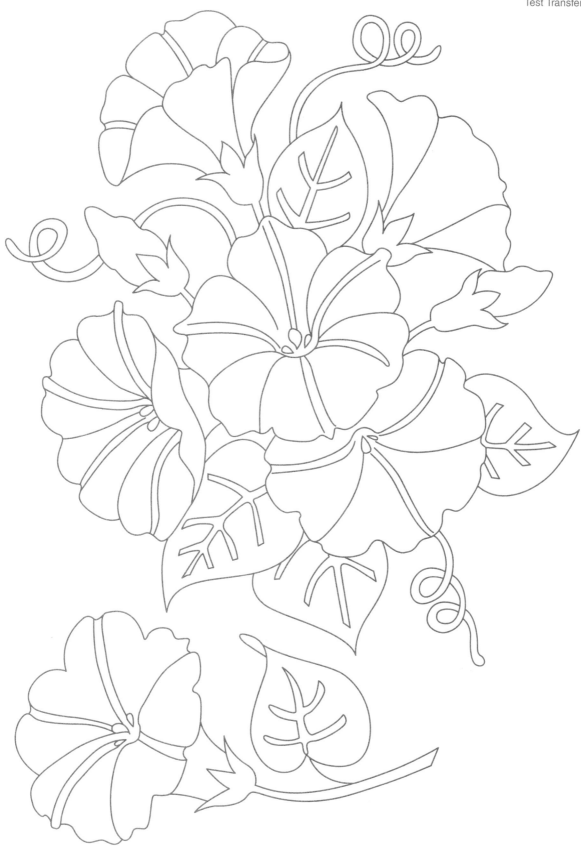

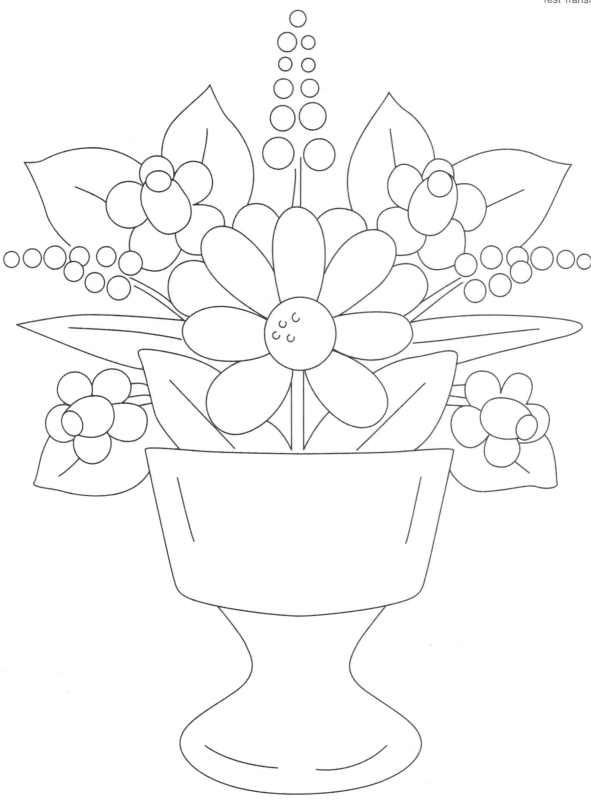

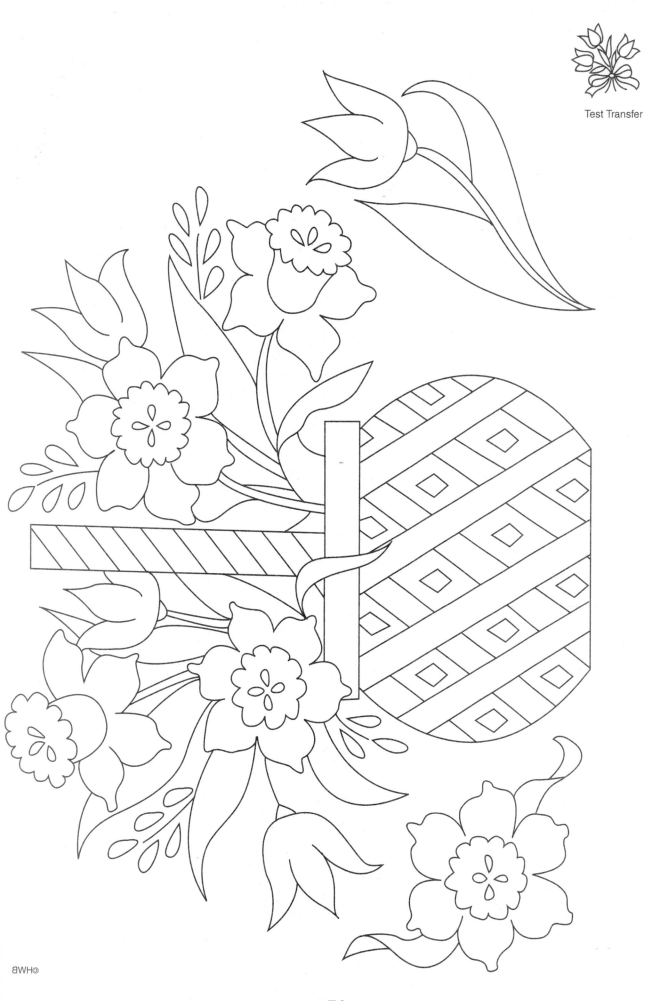

Test Transfer

©BWH

74

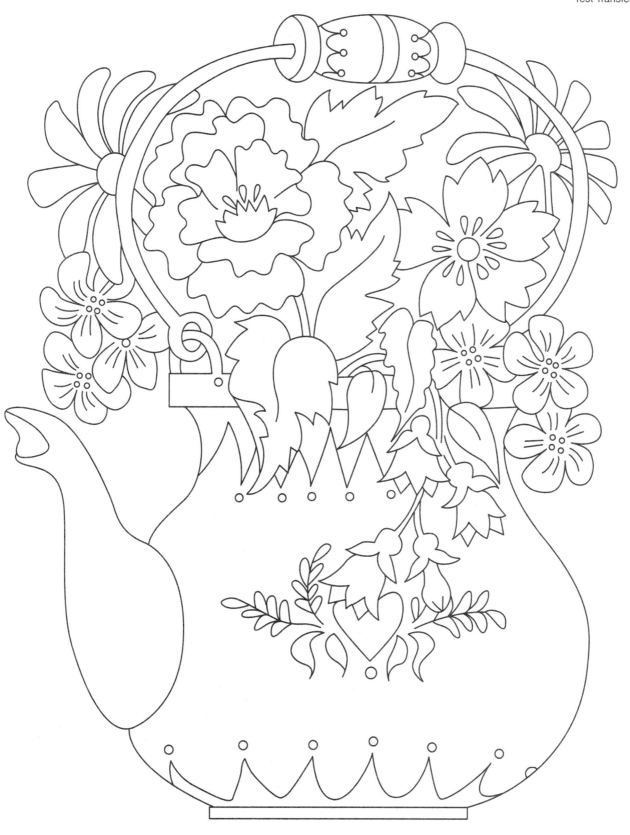

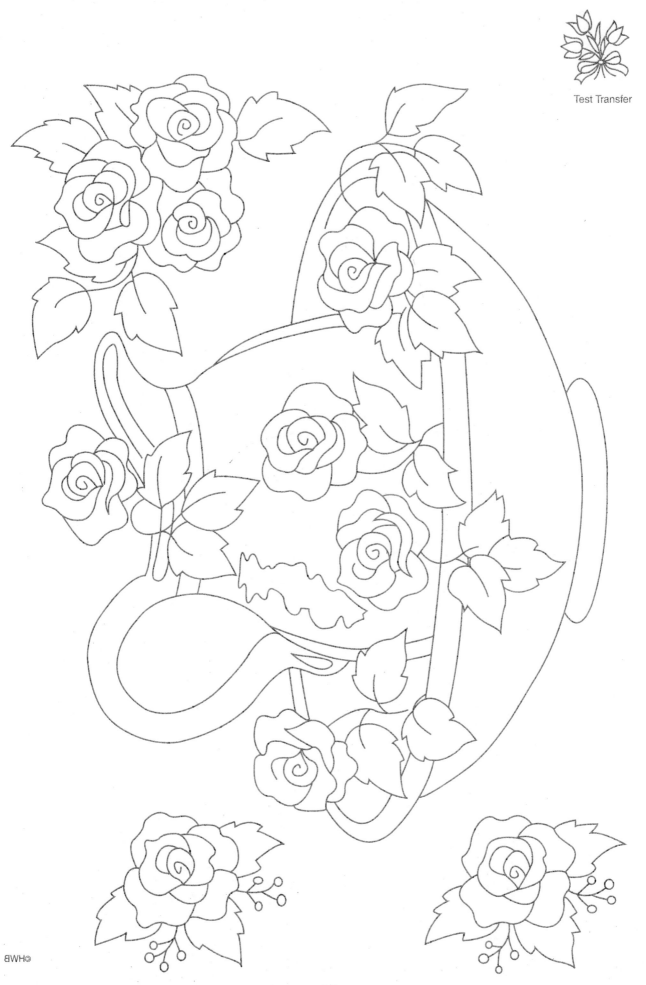

Test Transfer

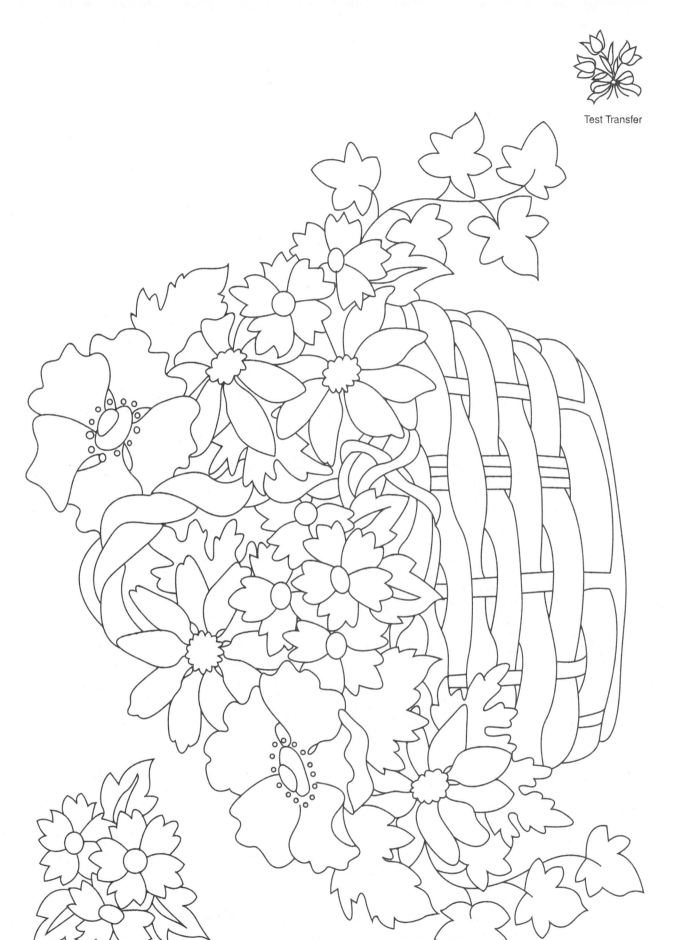

Test Transfer

©BWH

Test Transfer

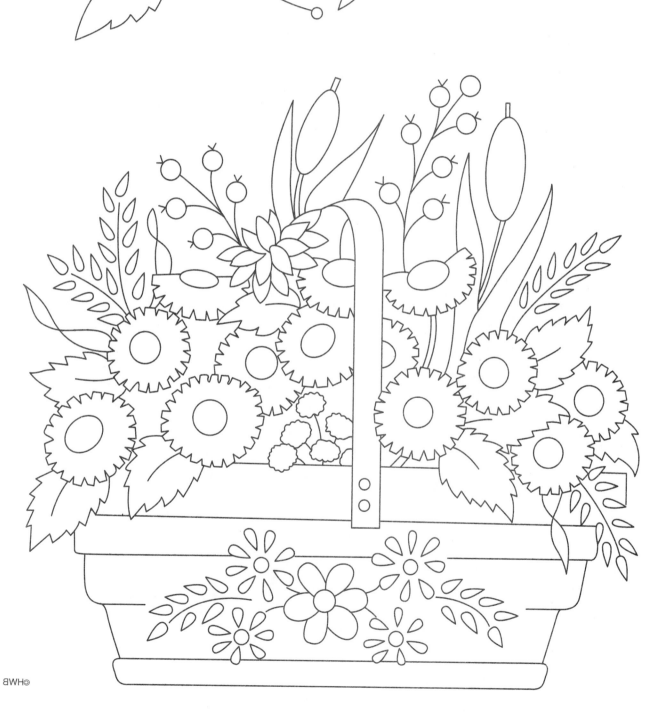

78

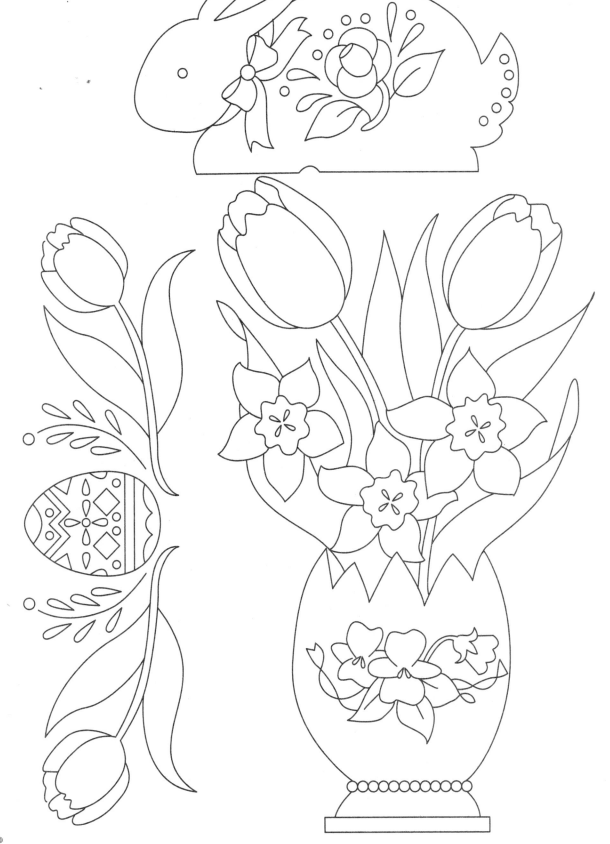

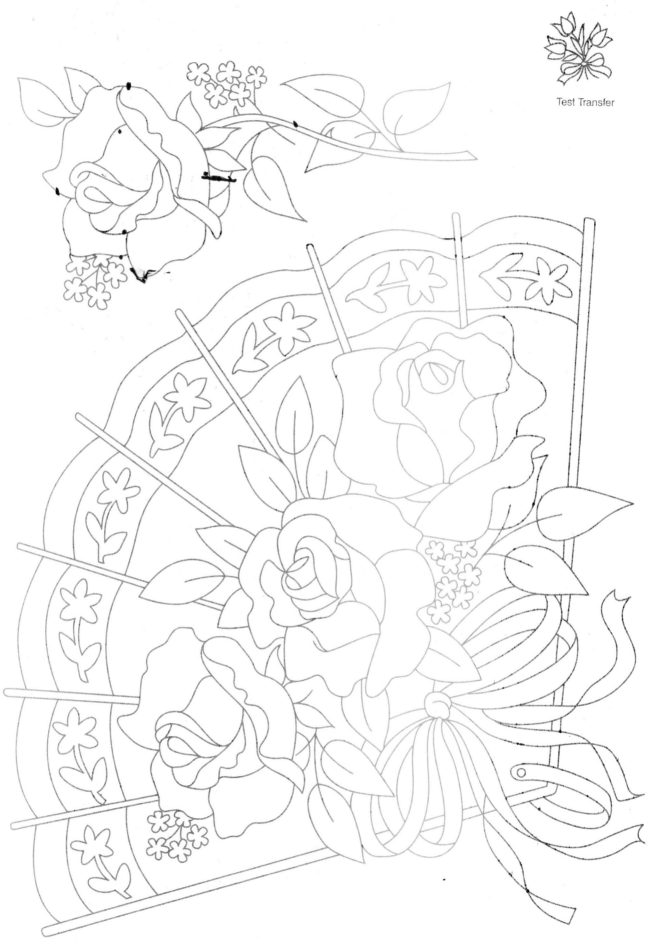

Test Transfer

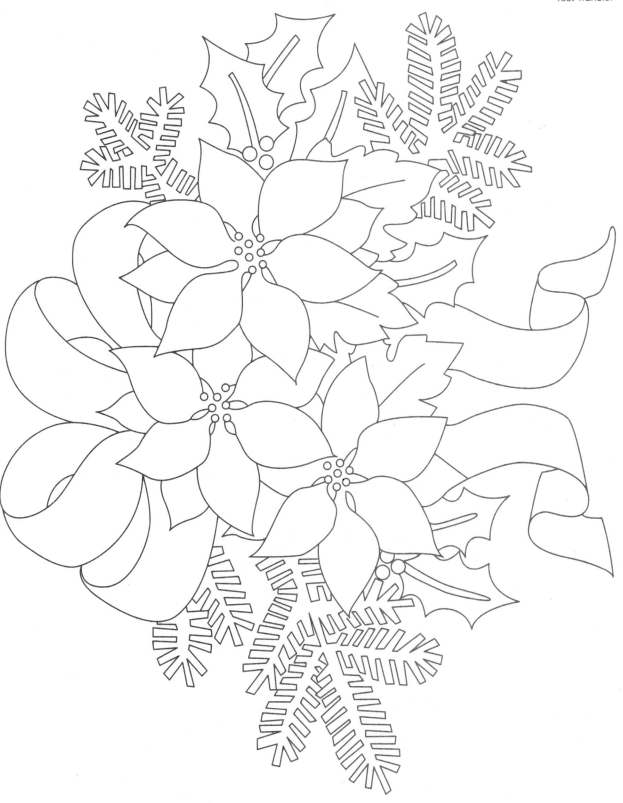

Test Transfer

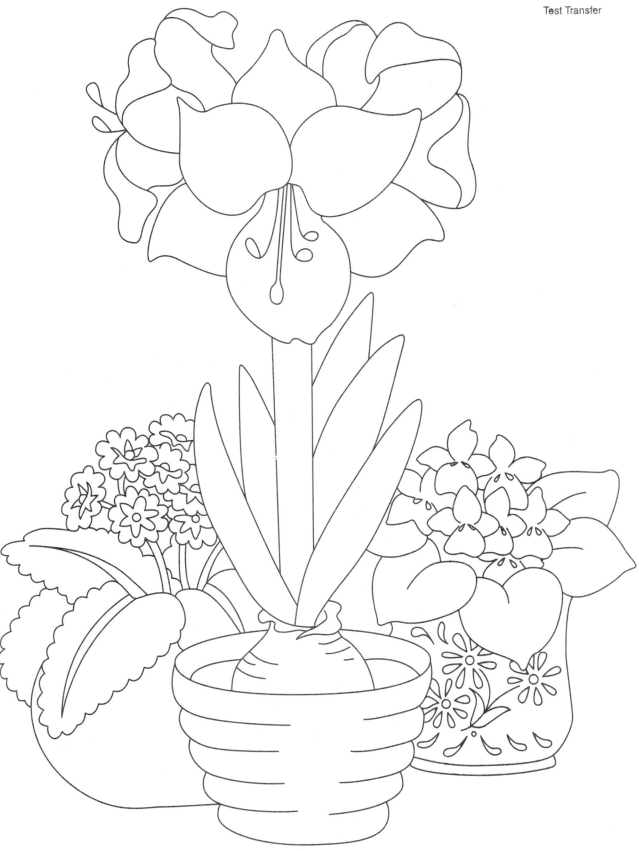

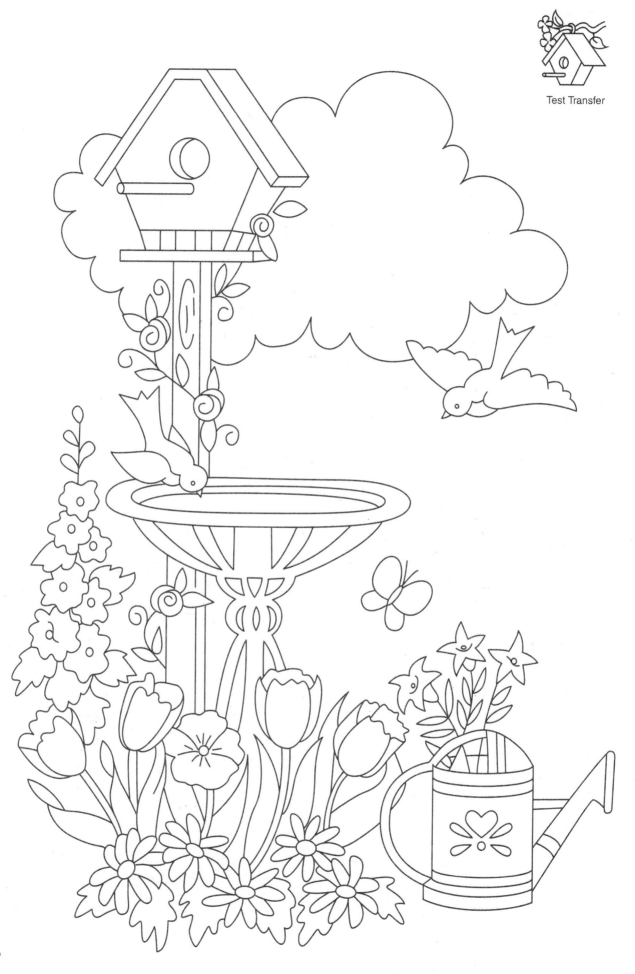

Test Transfer

83

Test Transfer

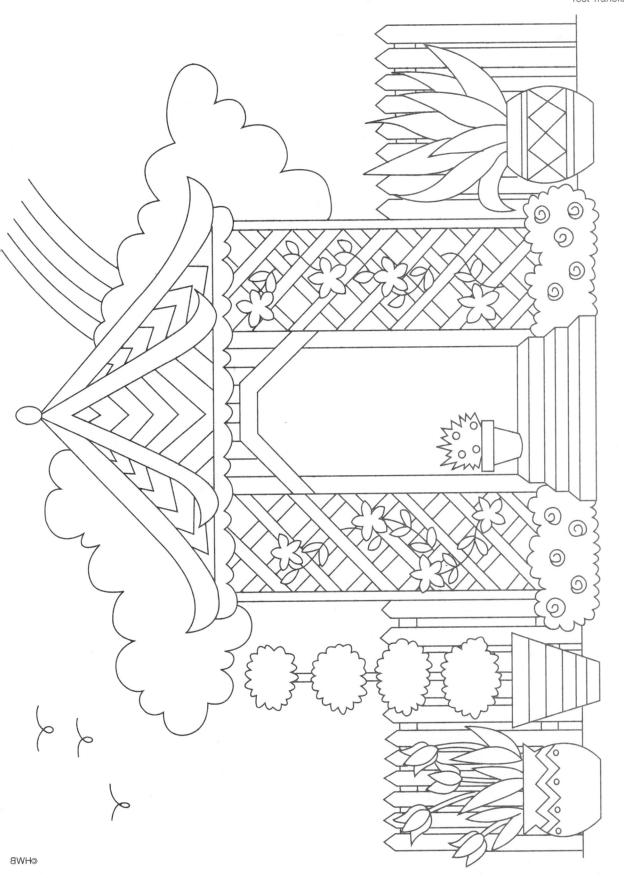

85

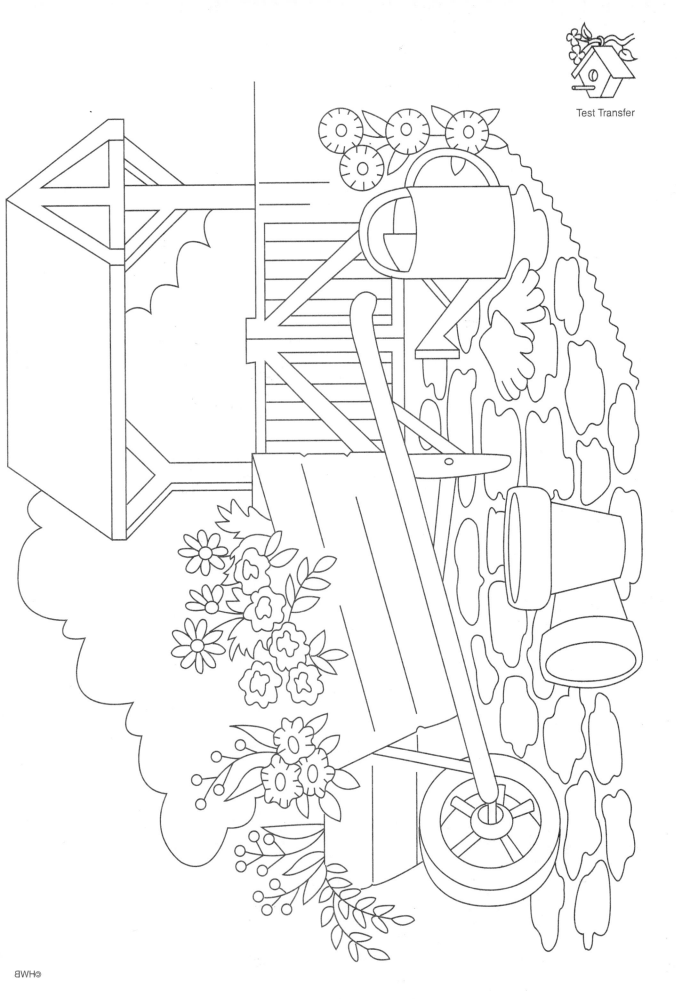

Test Transfer

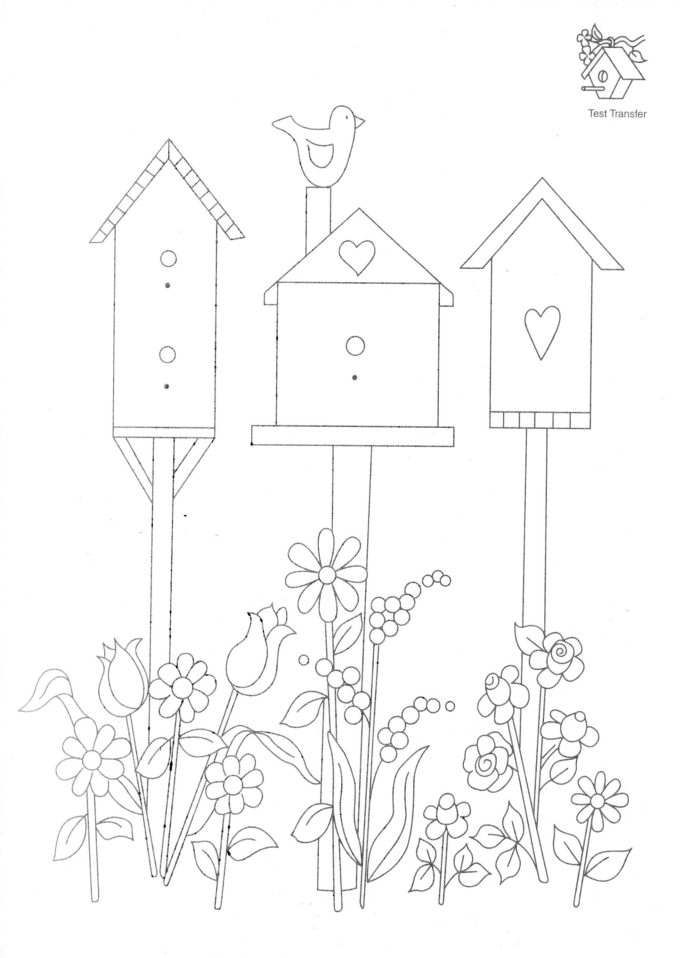

Test Transfer

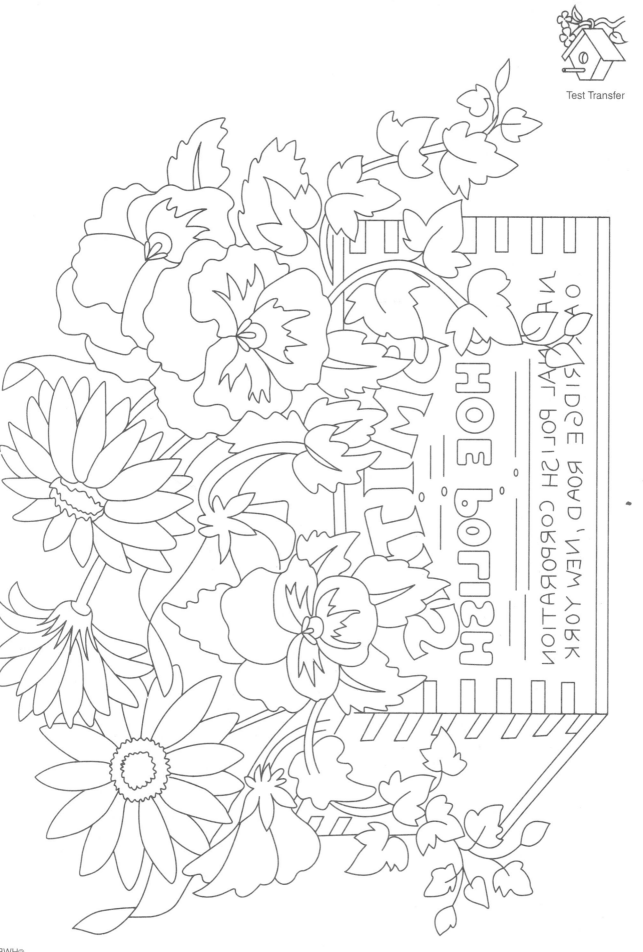

Test Transfer

SHOE POLISH TIME
OUTSIDE ROAD, NEW YORK
HORSH CORPORATION

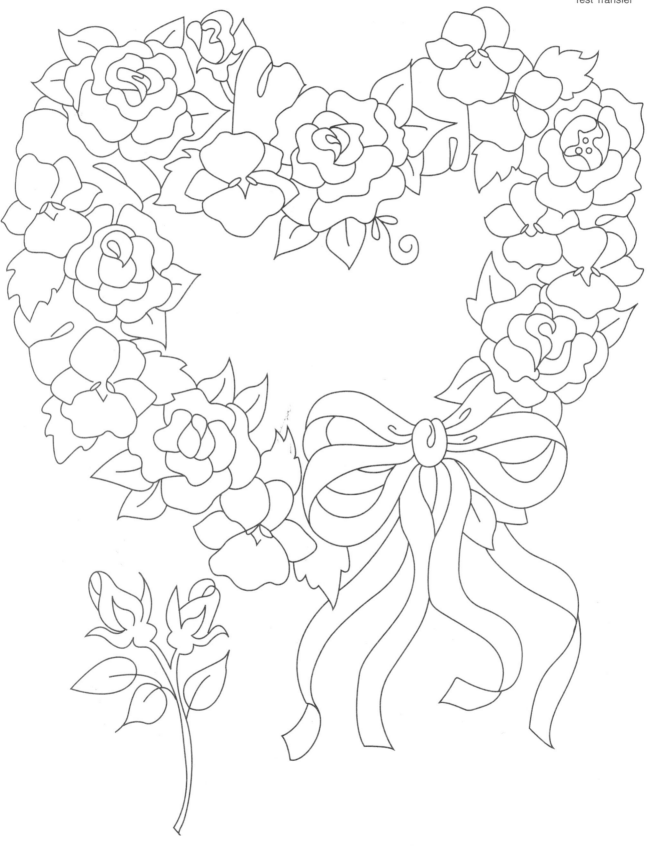

Test Transfer

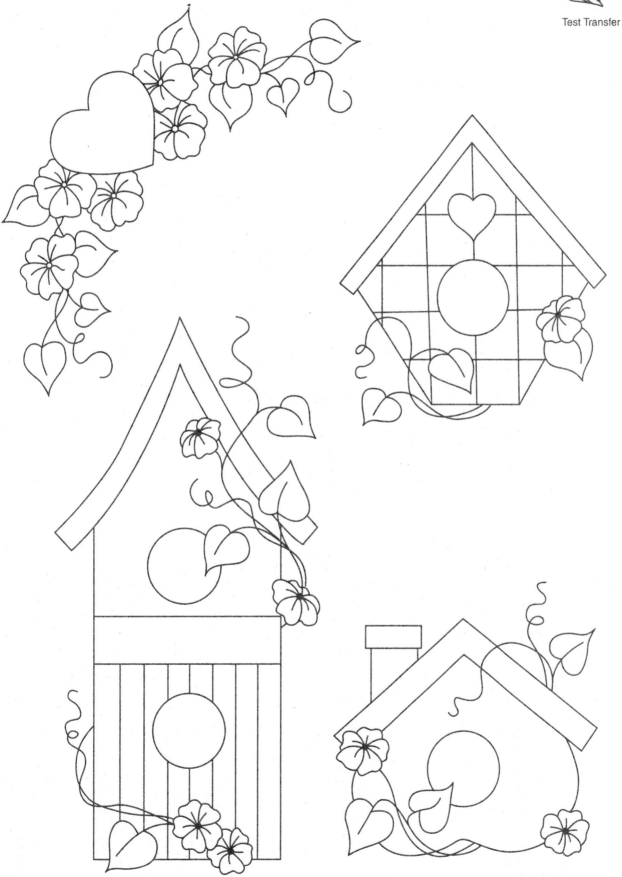

©HWB

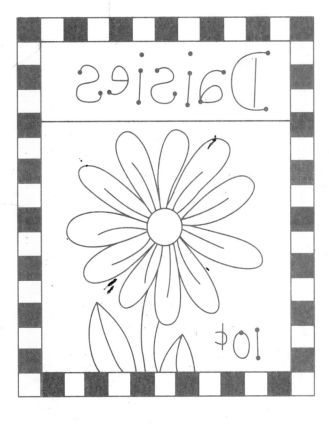

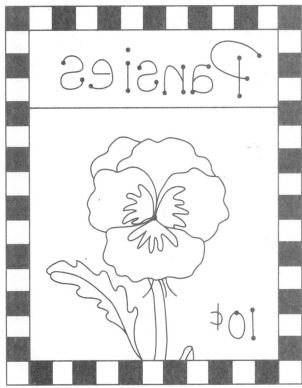

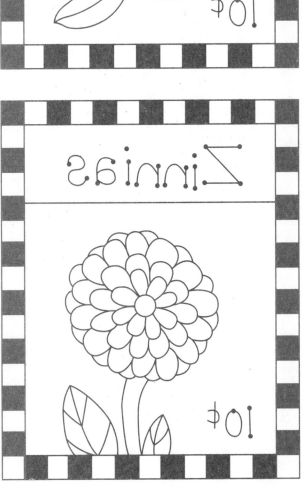

93

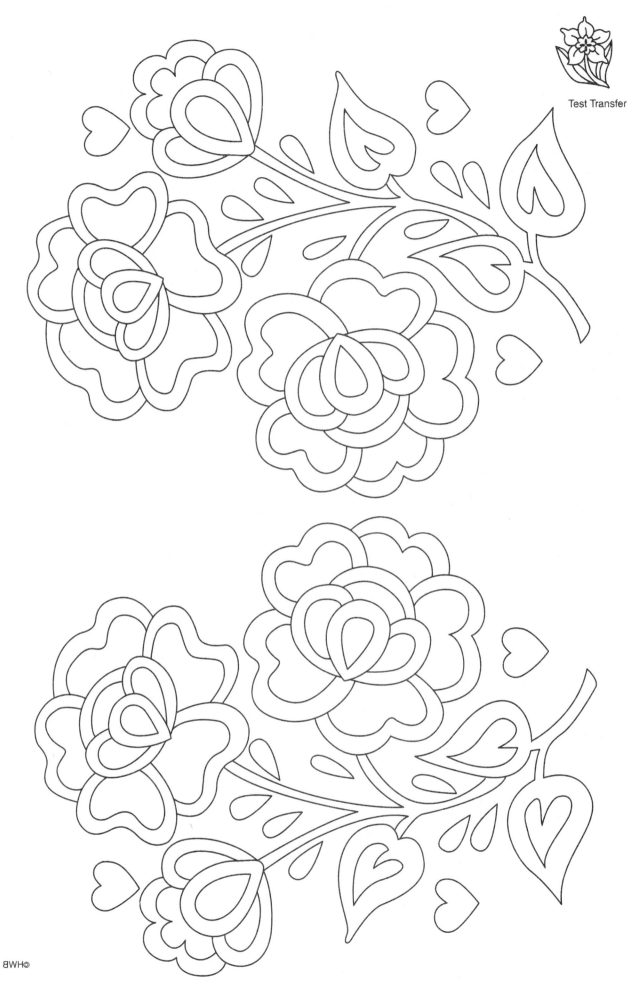

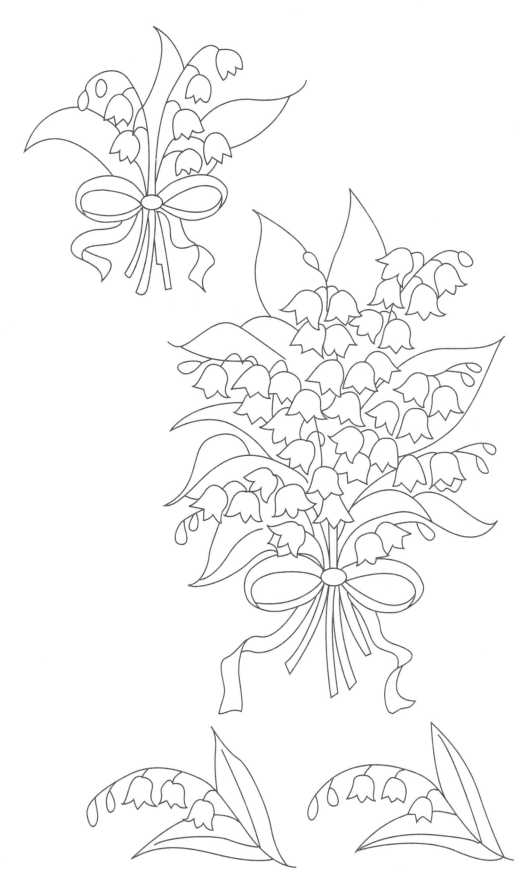

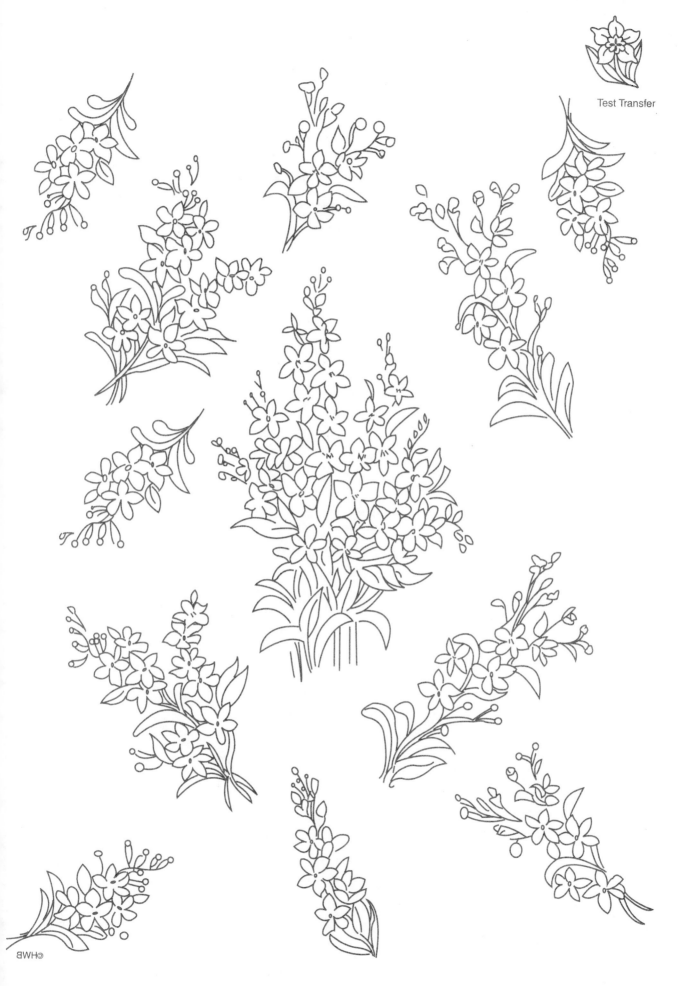

Test Transfer

©HWB

96

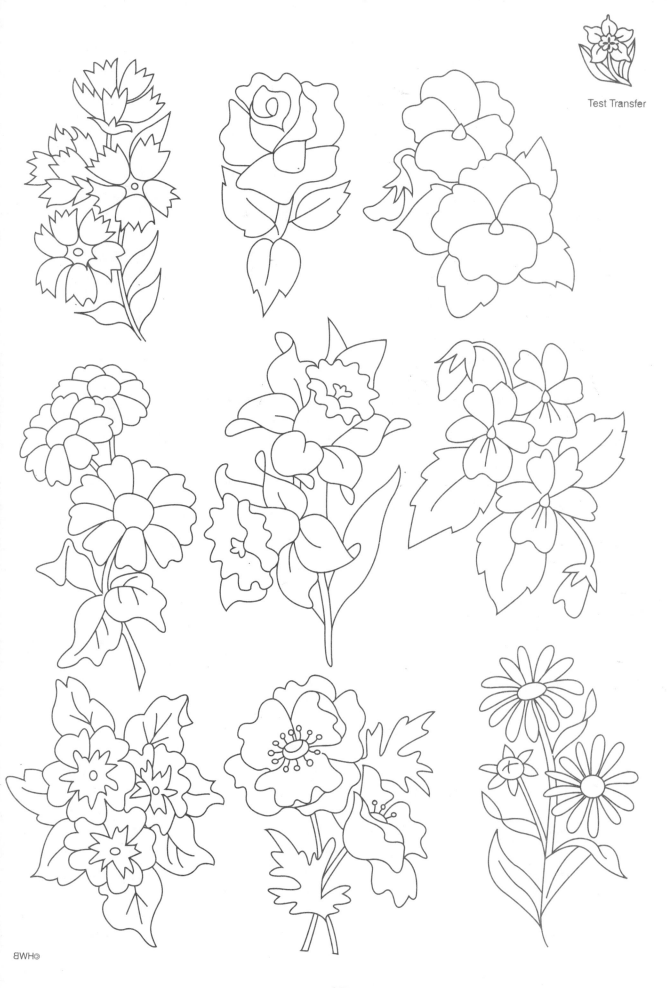

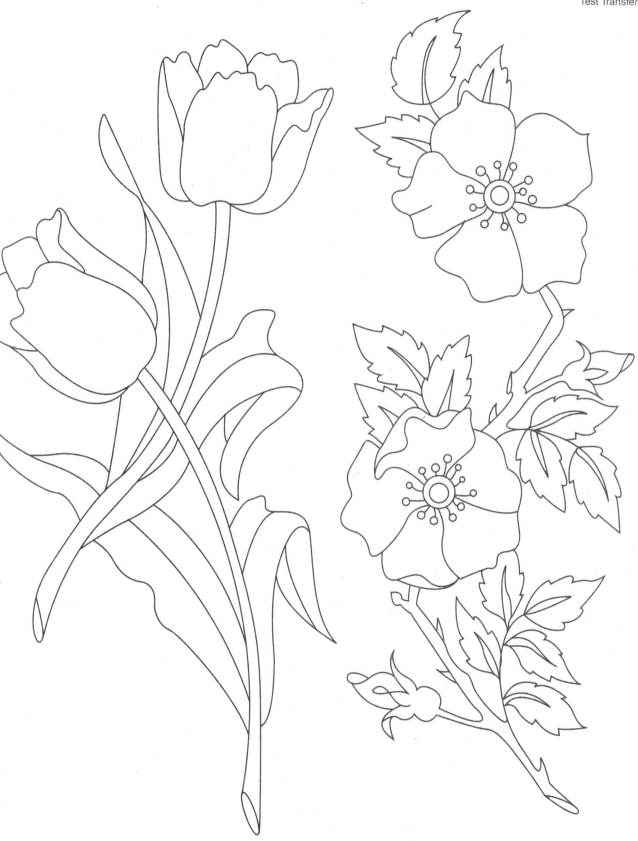

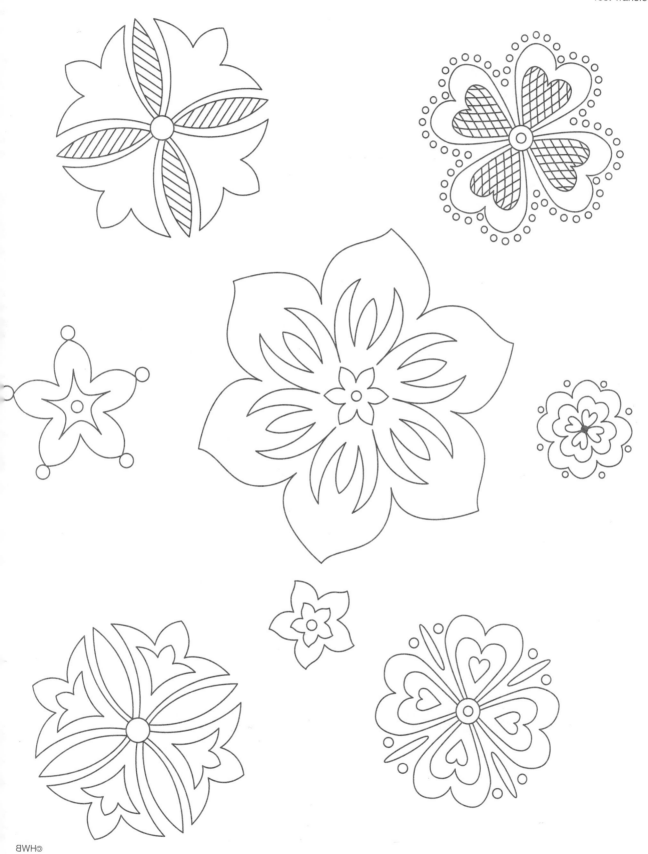

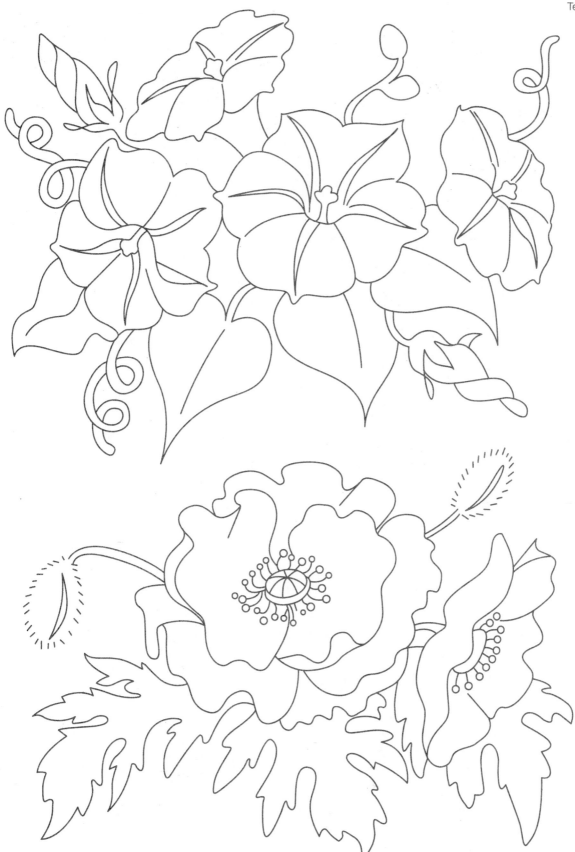

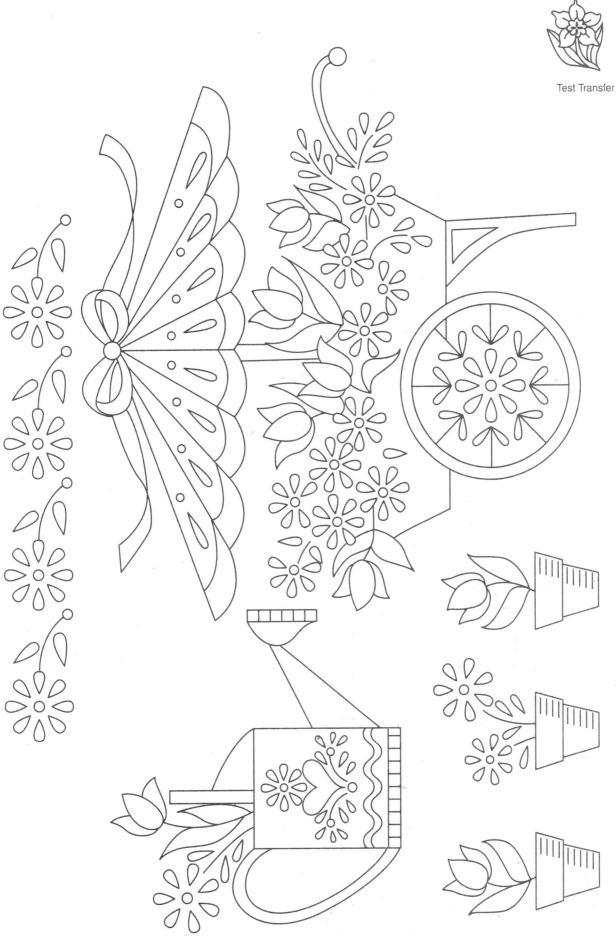

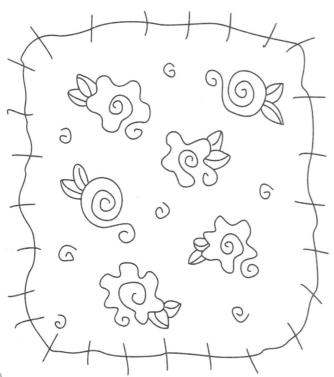

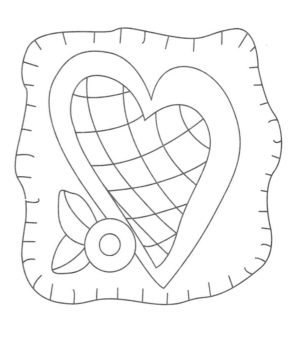

©BWH

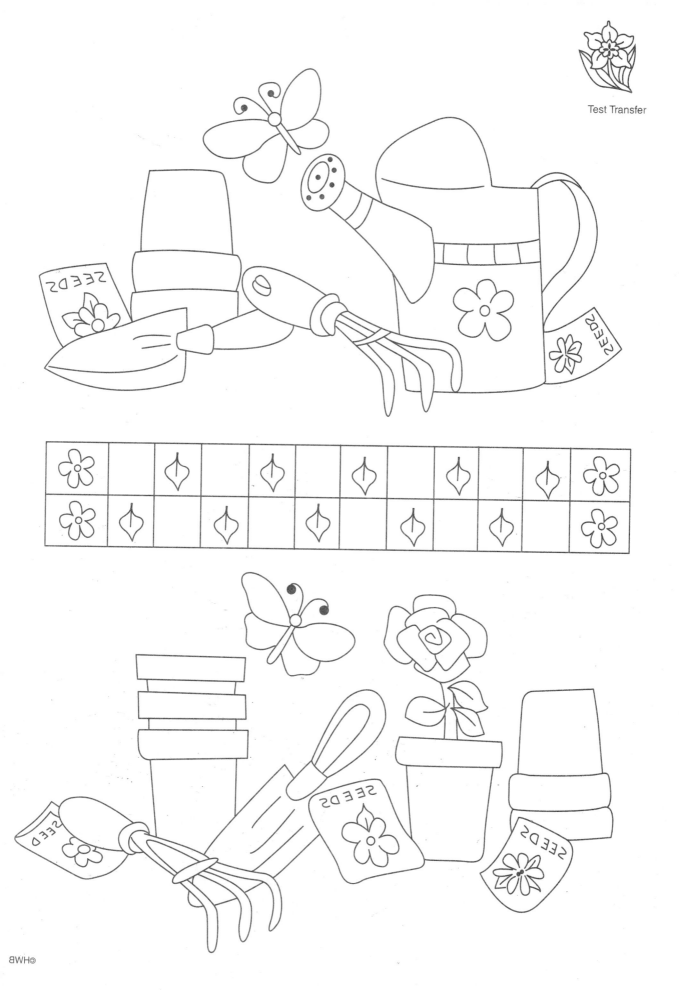

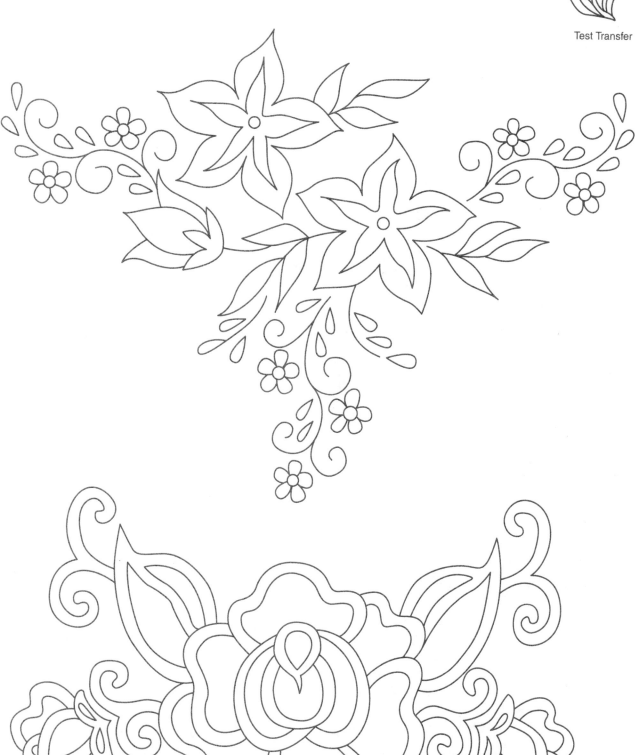

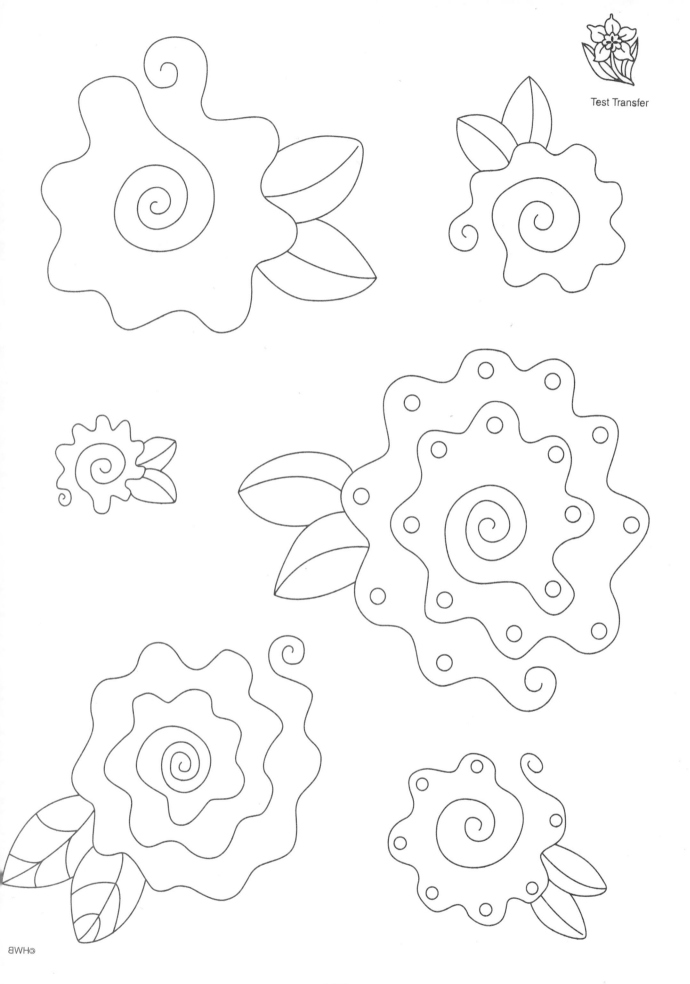

©HWB

105

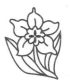

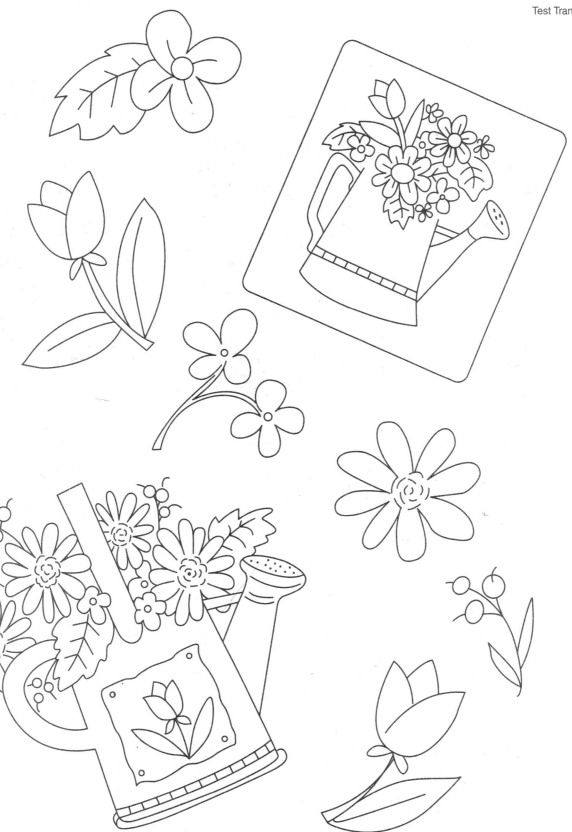

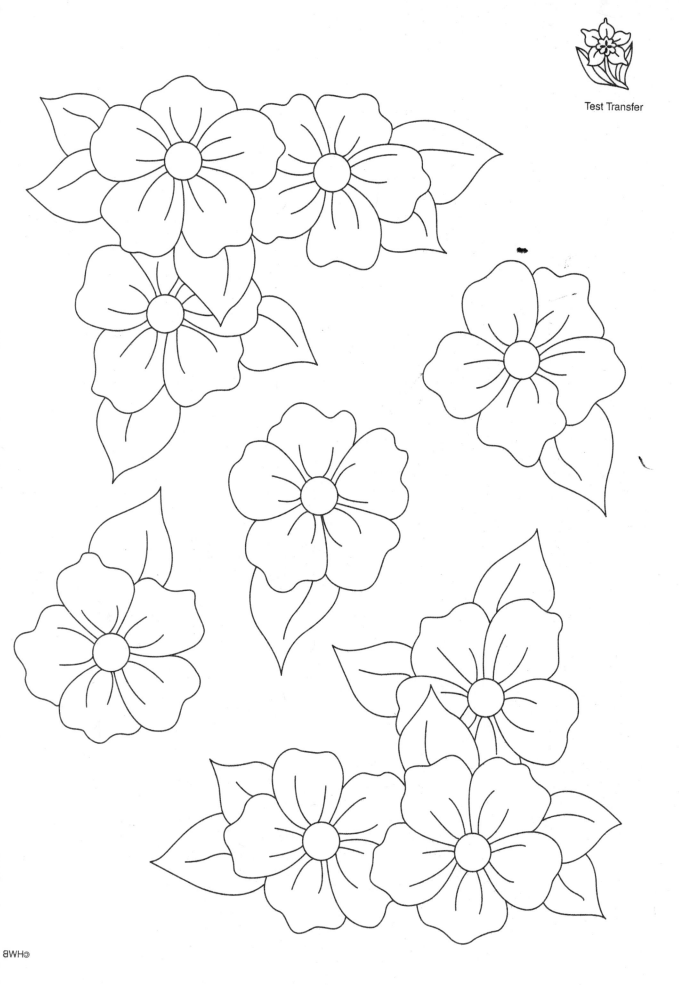

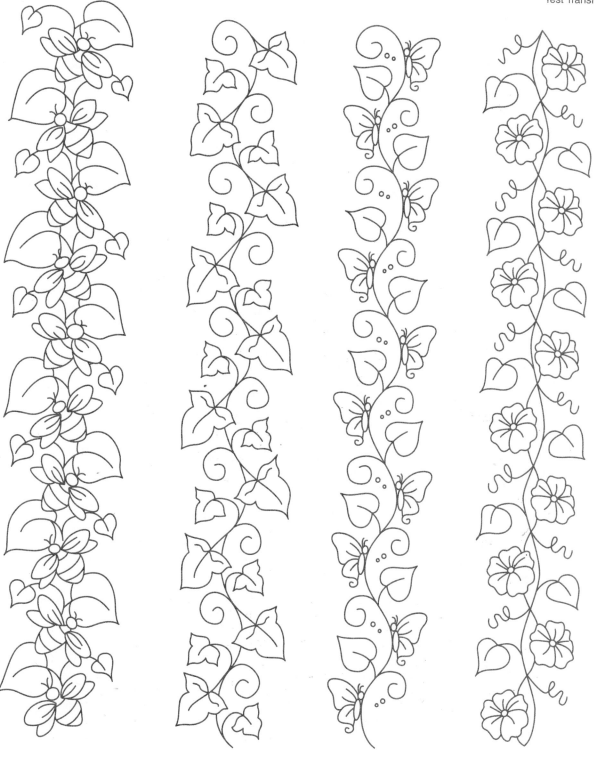

Test Transfer

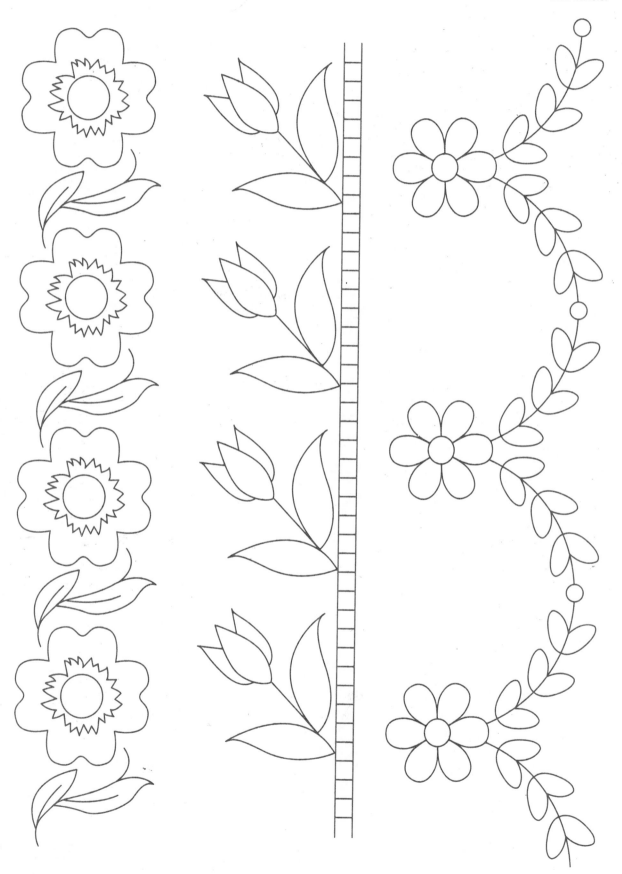

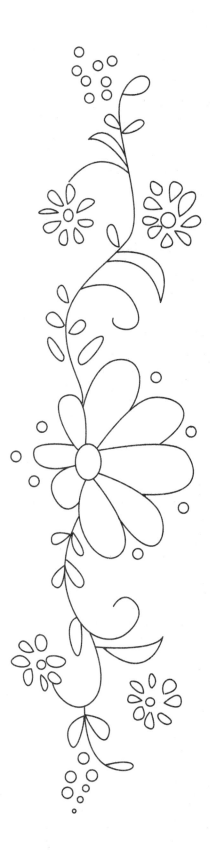

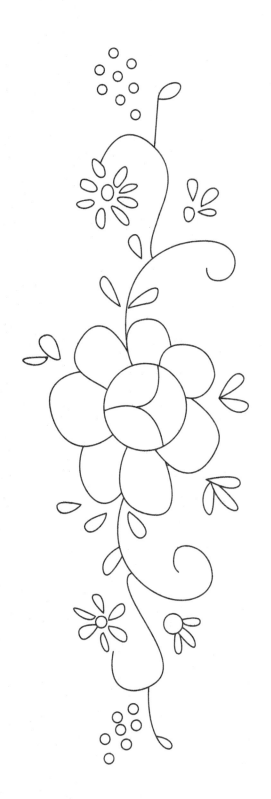

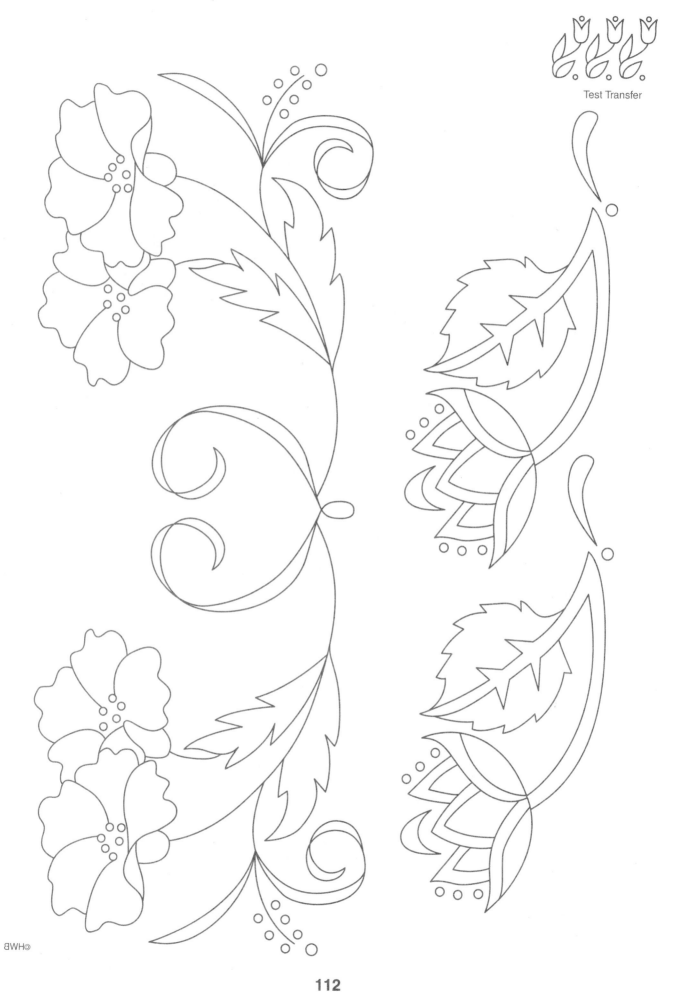

Test Transfer

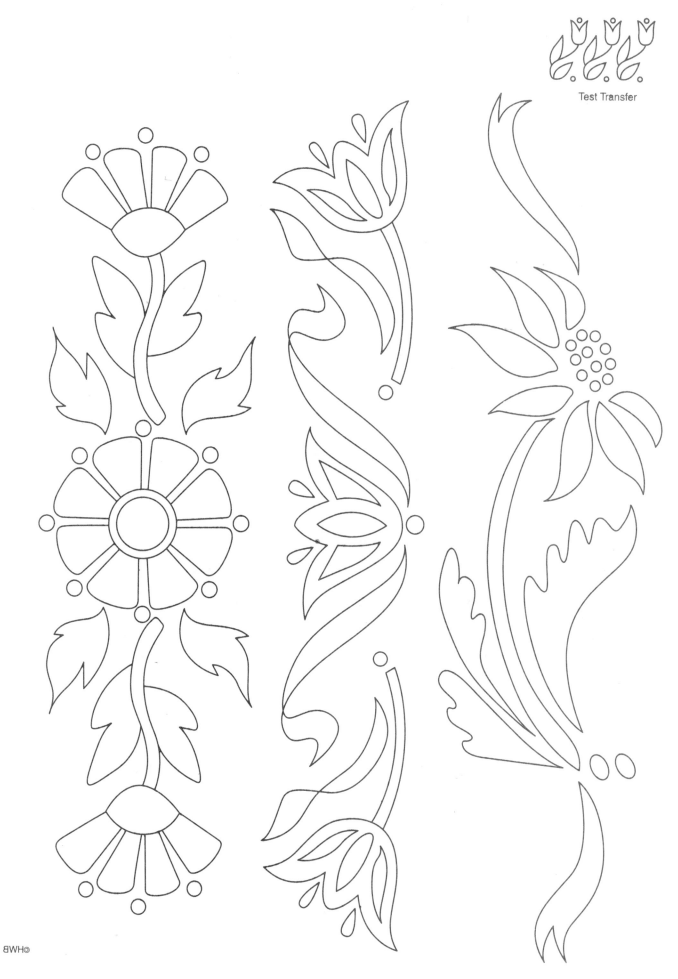

Test Transfer

BWH©

113

Test Transfer

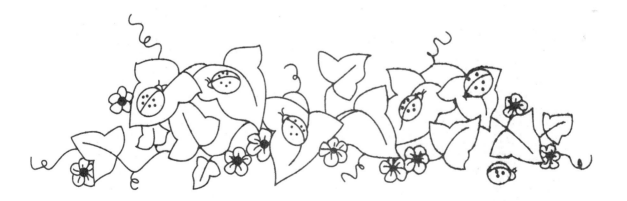

Test Transfer

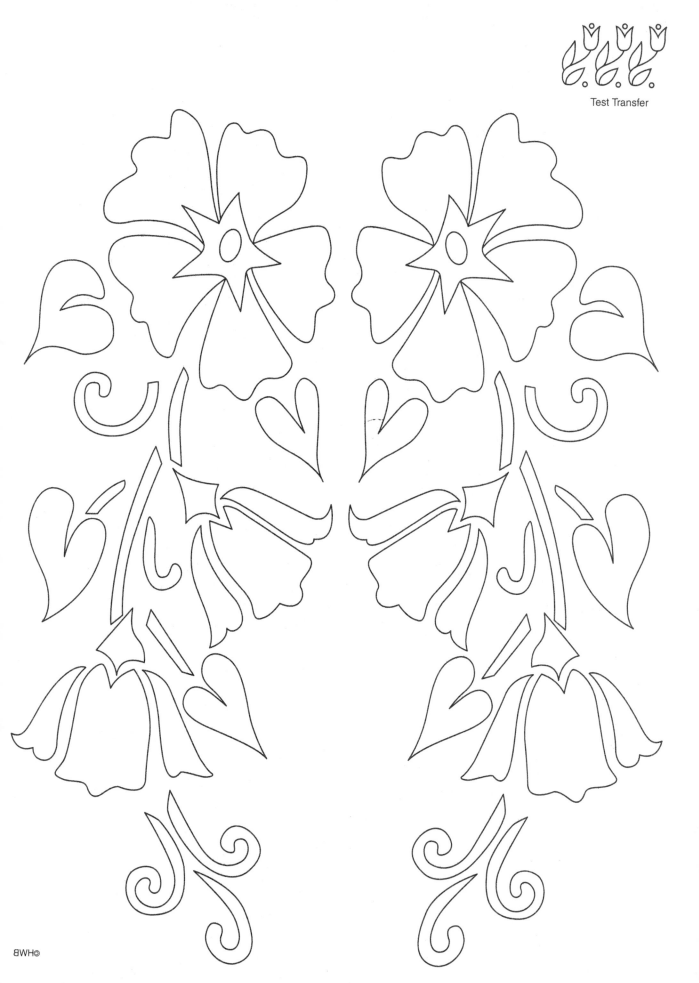

©BWH

115

Test Transfer

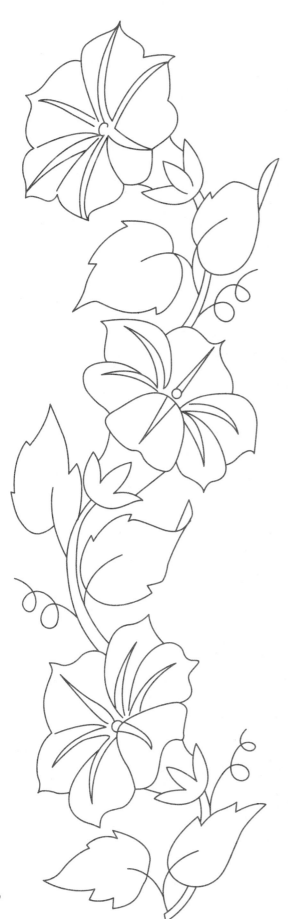
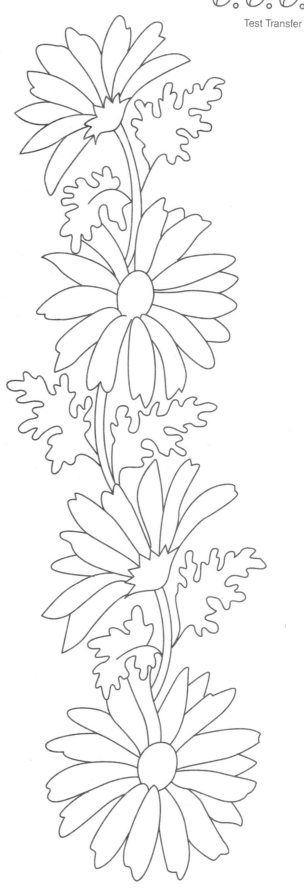

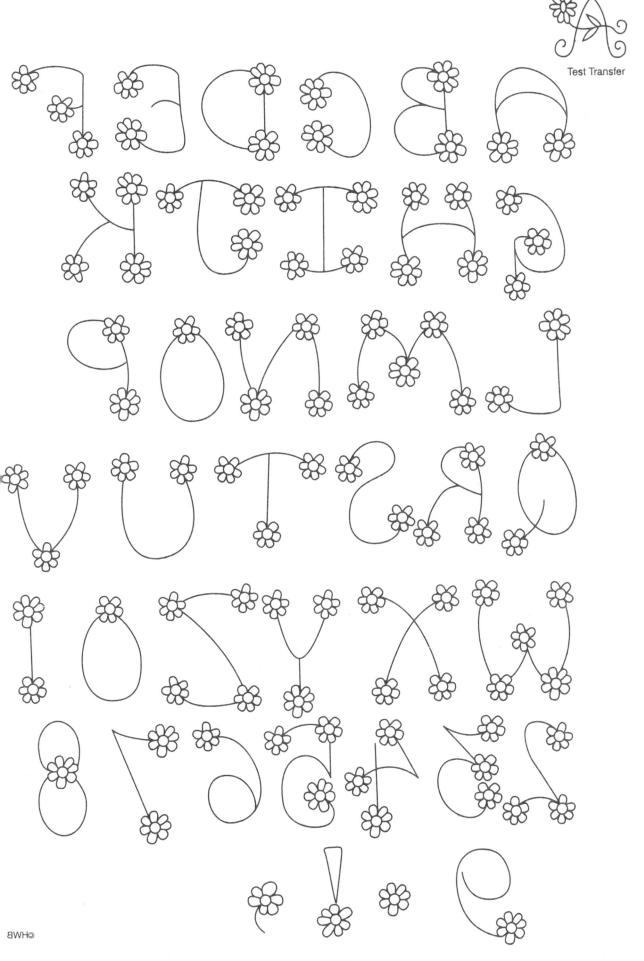

117

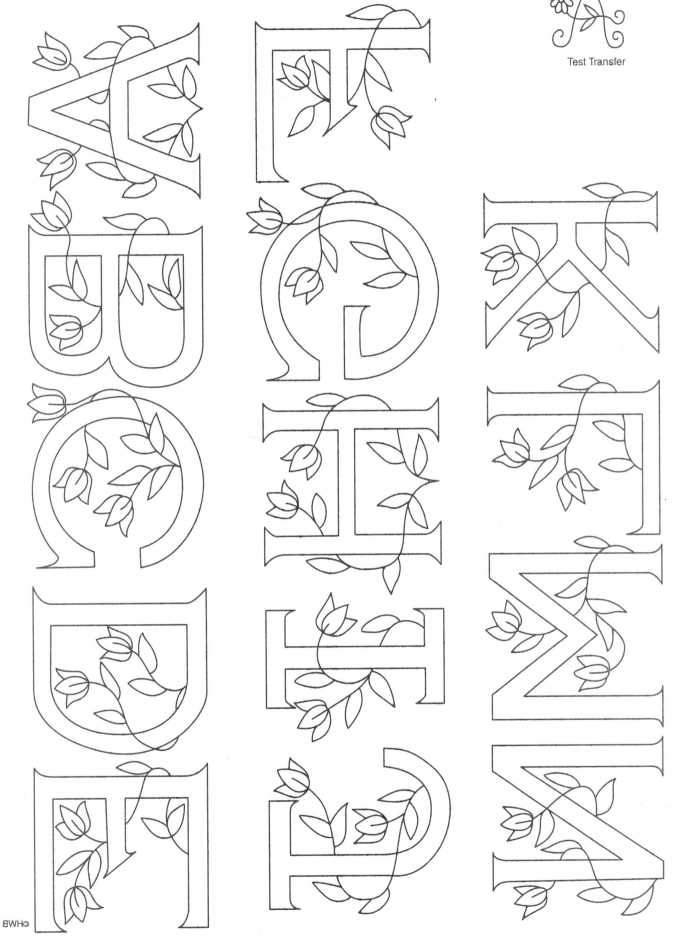

Test Transfer

BWH©

118